Come...
meet Jesus

through the eyes of
many of the world's greatest artists,
featuring 67 works of art

Rich Timmons

Come... meet Jesus

Unless otherwise indicated, all scripture quotations are taken from
The World English Bible. The World English Bible is in the Public Domain.
The World English Bible is a Trademark of eBible.org.

Photo Credits – ALAMY

Cover Photo – The Incredulity of Saint Thomas by Caravaggio – ALAMY

For information about special discounts for bulk purchases, please contact the author at: rt@ComeMeetJesus.art

www.ComeMeetJesus.art

ISBN 978-1-7374698-0-3 Hard Cover
ISBN 978-1-7374698-2-7 Soft Cover
ISBN 978-1-7374698-1-0 Digital FlipBook

Printed in the United States

To Julie,
my beautiful bride,
my best friend
and co-laborer.

"Artists are called and gifted
– personally by name –
to write, paint, sing, play
and dance to the glory of God."

Philip Graham Ryken

Foreword

Dear Reader,

How do we respond to Christ? What do we do with His claims to be our Messiah and Redeemer, the very Son of God?

Art is a precious gift from our Creator, a powerful medium of communication and expression. When truth is shared together with beauty, the potential for great response and effect is stunning.

My dear friend, Rich Timmons, has provided a feast of beauty to share with you the truth of the meaning and significance of Jesus. You have in your hands the opportunity to consider, to look closer, to be moved, to believe, and to know God through Christ. My prayer for you, dear reader, is that you open your heart and your eyes to "Behold, the Lamb of God, who takes away the sins of the world!" He longs to call you friend and has opened the way forever to peace with God.

This collection allows you to see the responses of artists who have gazed into the truth and beauty of Jesus Christ. With these expressive gifts, take time to consider Christ's divinity, humanity, ministry, death, resurrection, ascension, and promise to return. I encourage you to look closely, and when you get to the ugliest symbol of cruel torture and death, do not turn away. See God's beauty on display as His own Son willingly laid down His life for you. Savor the intense and incomprehensible scope of His love for you. Delight in Christ who fulfilled all that was promised for our redemption in every gracious, artistic detail of God's perfect plan.

What can you do in response? Rich Timmons lays out the options for response at the end of this book. For a heart that knows God or longs for Him, worship and praise will burst forth upon consideration of the magnificence of Christ. My favorite response of a heart moved by beauty to praise God was shared by my beloved mentor, Tom Brown: "My compliments to the Maker!" Such a response to art shows the gratitude for the beauty shared, but even more importantly shows that the viewer's gaze is lifted to the very face of God, the Artist, Maker, Creator, and Author of our salvation.

May you be moved to respond to the living God through Jesus.

With love,

Karen Piranian Burgman

Introduction

The purpose of this book depends on who you are, and where you are in your spiritual journey. Are you agnostic? Read on. I hope you change your mind. Are you a seeker? Read on. You'll meet your Savior here. Are you a believer and follower of Jesus Christ? Great! Read on. Regardless of where you are on your journey, trust me, you will be blessed.

No one person in all of history has ever been written about, sung about, taught about and, yes, even painted about than Jesus Christ. If you were to do a Google word search of Jesus Christ, you will find a staggering 471 million results. No one even comes close.

Bible scholars much smarter than I am, suggest there are more than 100 Old Testament prophetic Scriptures, and every one of those 100 prophecies were fulfilled by the One and only Jesus Christ. Professor Peter W. Stoner, who authored *Science Speaks* stated that the probability of just eight particular prophecies being fulfilled by Jesus Christ is 1 in 10^{17}, (1,000,000,000,000,000,000,000) (100 Quadrillion). This number: 1 in 10^{17}, has been illustrated as follows: If we take 100 Quadrillion silver dollars and lay them on the face of the state of Texas, they'll cover all of the state two feet deep. Now mark one of these silver dollars with a red dot, and stir the whole mass thoroughly, all over the state. Blindfold a man and tell him that he can travel as far as he wishes, but he must pick up one silver dollar and say, "It's the one with the red dot." What chance would he have of getting the right one?

One in 1,000,000,000,000,000,000,000!

Jesus, did in fact fulfill every single prophecy.

Perhaps you never thought about Jesus from an artist's point of view. Maybe this book will cause you to want to have a closer walk with Him. Maybe, just maybe, after you absorb all that you have just seen and read, it will cause you to invite Jesus to be your Savior. He will give you eternal life in heaven and a personal relationship with Him right here and now. Deuteronomy 4:29 says, "If you will seek the LORD your God, you will find Him if you search for Him with all your heart and all your soul."

 Enjoy your journey,

 [signature]

*Professor Stoner's statement was validated by The American Scientific Affiliation.

The Greatest Life Ever Lived

He was born in an obscure village, the child of a peasant woman.

He grew up in still another village where He worked in a carpenter shop until He was thirty.

Then for three years He was an itinerant preacher. He never wrote a book.

He never held an office. He never had a family or owned a house.

He didn't go to college. He never visited a big city.

He never traveled more than two hundred miles from the place He was born.

He did none of these things that one usually associated with greatness.

He had no credentials but Himself.

He was only thirty-three when the tide of public opinion turned against Him.

His friends ran away.

He was turned over to His enemies and went through the mockery of a trial.

He was nailed to a cross between two thieves.

While He was dying, His executioners gambled for His clothing,

the only property He had on earth.

When He was dead, He was laid in a borrowed grave through the pity of a friend.

Twenty centuries have come and gone,

and today He is the central figure of the human race

and the leader of mankind's progress.

All the armies that have ever marched,

all the navies that have ever sailed,

all the parliaments that have ever sat,

all the kings that have ever reigned,

put together,

have not effected the life of man on the earth as that one solitary man.

James Allan Francis (1864–1928)

Contents

The content of this book is a chronological, historical timeline
of the life of Jesus through the eyes of 67 of the world's greatest artists.

PLEASE NOTE

Wherever you see RED text in the scriptures, it is informing the reader that Jesus is speaking.

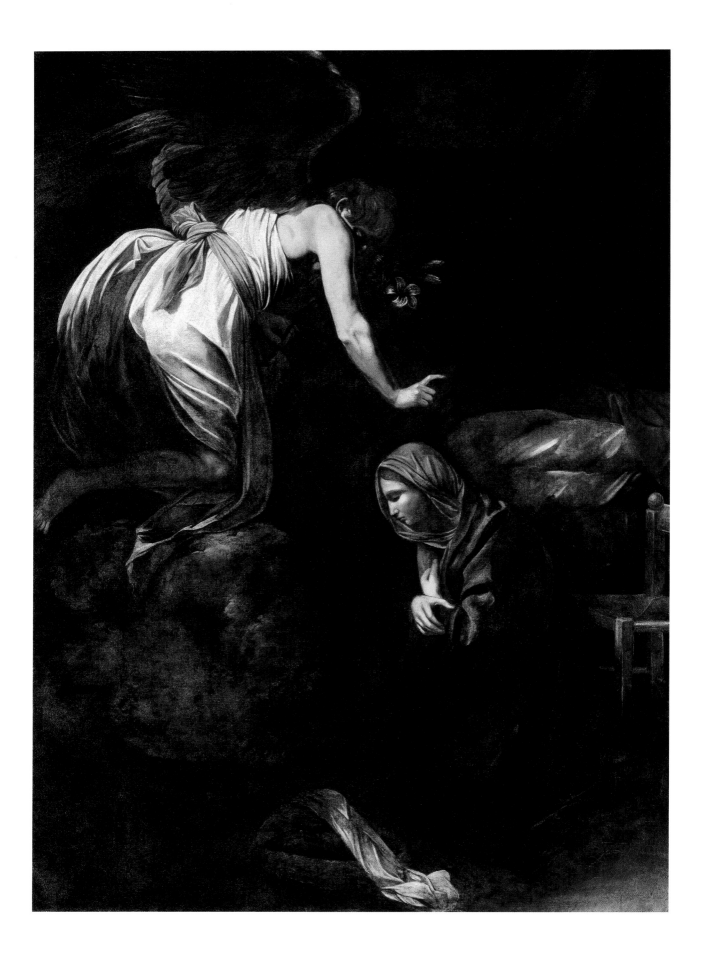

The Annunciation *Luke 1:26-38*

Now in the sixth month, the angel Gabriel was sent from God to a city of Galilee named Nazareth, to a virgin pledged to be married to a man whose name was Joseph, of David's house. The virgin's name was Mary. Having come in, the angel said to her, "Rejoice, you highly favored one! The Lord is with you. Blessed are you among women!" But when she saw him, she was greatly troubled at the saying, and considered what kind of salutation this might be. The angel said to her, "Don't be afraid, Mary, for you have found favor with God. Behold, you will conceive in your womb and give birth to a son, and shall name Him 'Jesus.' He will be great and will be called the Son of the Most High. The Lord God will give Him the throne of His father David, and He will reign over the house of Jacob forever. There will be no end to His Kingdom." Mary said to the angel, "How can this be, seeing I am a virgin?" The angel answered her, "The Holy Spirit will come on you, and the power of the Most High will overshadow you. Therefore also the holy one who is born from you will be called the Son of God. Behold, Elizabeth your relative also has conceived a son in her old age; and this is the sixth month with her who was called barren. For nothing spoken by God is impossible." Mary said, "Behold, the servant of the Lord; let it be done to me according to your word." Then the angel departed from her.

Caravaggio 1571-1610
Caravaggio was an Italian painter active in Rome for most of his artistic life. His paintings combine a realistic observation of the human state, both physical and emotional, with a dramatic use of lighting, which had a formative influence on Baroque painting. Caravaggio employed close physical observation with a dramatic use of chiaroscuro (the theatrical use of light and dark shadows) that came to be known as tenebrism. He made the technique a dominant stylistic element. Caravaggio vividly expressed crucial moments and scenes, often featuring violent struggles, torture, and death. He worked rapidly, with live models, preferring to forgo drawings and work directly onto the canvas.

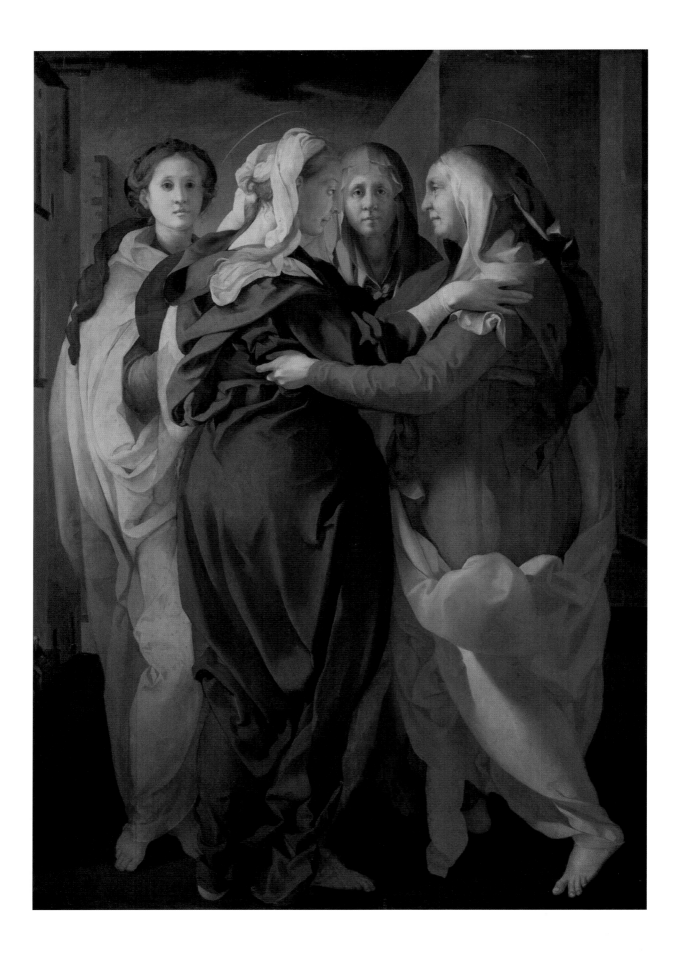

Mary Visits Elizabeth *Luke 1:39-45*

Mary arose in those days and went into the hill country with haste, into a city of Judah, and entered into the house of Zacharias and greeted Elizabeth. When Elizabeth heard Mary's greeting, the baby leaped in her womb; and Elizabeth was filled with the Holy Spirit. She called out with a loud voice and said, "Blessed are you among women, and blessed is the fruit of your womb! Why am I so favored, that the mother of my Lord should come to me? For behold, when the voice of your greeting came into my ears, the baby leaped in my womb for joy! Blessed is she who believed, for there will be a fulfillment of the things which have been spoken to her from the Lord!"

Mary said, "My soul magnifies the Lord. My spirit has rejoiced in God my Savior, for He has looked at the humble state of His servant. For behold, from now on, all generations will call me blessed. For He who is mighty has done great things for me. Holy is His name. His mercy is for generations and generations on those who fear Him. He has shown strength with His arm. He has scattered the proud in the imagination of their hearts. He has put down princes from their thrones, and has exalted the lowly. He has filled the hungry with good things. He has sent the rich away empty. He has given help to Israel, His servant, that He might remember mercy, as He spoke to our fathers, to Abraham and His offspring forever." Mary stayed with her about three months, and then returned to her house.

Jacopo Carucci 1494-1557
Carucci, usually known as Pontormo, was an Italian Mannerist painter from the Florentine School. Orphaned at a young age, he was described as a lonely, melancholy artist whose work reflected both passionate genius and unusual experimentation. He is famous for his use of twining poses, coupled with ambiguous perspective; his figures often seem to float in an uncertain environment, unhampered by the forces of gravity. At the age of eighteen, Pontormo was apprenticed to Leonardo da Vinci. Around 1517, Pontormo took on a pupil, Bronzino, who adopted his style and developed into one of the greatest Mannerist painters.

Joseph's Dream *Matthew 1:18-25*

Now the birth of Jesus Christ was like this: After His mother, Mary, was engaged to Joseph, before they came together, she was found pregnant by the Holy Spirit. Joseph, her husband, being a righteous man, and not willing to make her a public example, intended to put her away secretly. But when he thought about these things, behold, an angel of the Lord appeared to him in a dream, saying, "Joseph, son of David, don't be afraid to take to yourself Mary as your wife, for that which is conceived in her is of the Holy Spirit. She shall give birth to a Son. You shall name Him Jesus, for it is He who shall save His people from their sins."

Now all this has happened that it might be fulfilled which was spoken by the Lord through the prophet, saying, "Behold, the virgin shall be with child, and shall give birth to a Son. They shall call His name Immanuel," which is, being interpreted, "God with us." Joseph arose from his sleep, and did as the angel of the Lord commanded him, and took his wife to himself; and didn't know her sexually until she had given birth to her firstborn Son. He named Him Jesus.

Anton Raphael Mengs 1728-1779
Mengs was a German Bohemian painter who became one of the precursors to Neoclassical painting. In 1749, he was appointed first painter to Frederick Augustus, Elector of Saxony, but this did not prevent him from continuing to spend much of his time in Rome. There he married Margarita Guazzi. He converted to Catholicism, and in 1754 he became director of the Vatican school of painting. His closeness to Johann Joachim Winckelmann, a well-known German historian, enhanced his historical importance. Mengs came to share Winckelmann's enthusiasm for classical antiquity and worked to establish the dominance of Neoclassical painting. At the same time, however, the influence of the Roman Baroque remained strong in his work, particularly in his religious paintings.

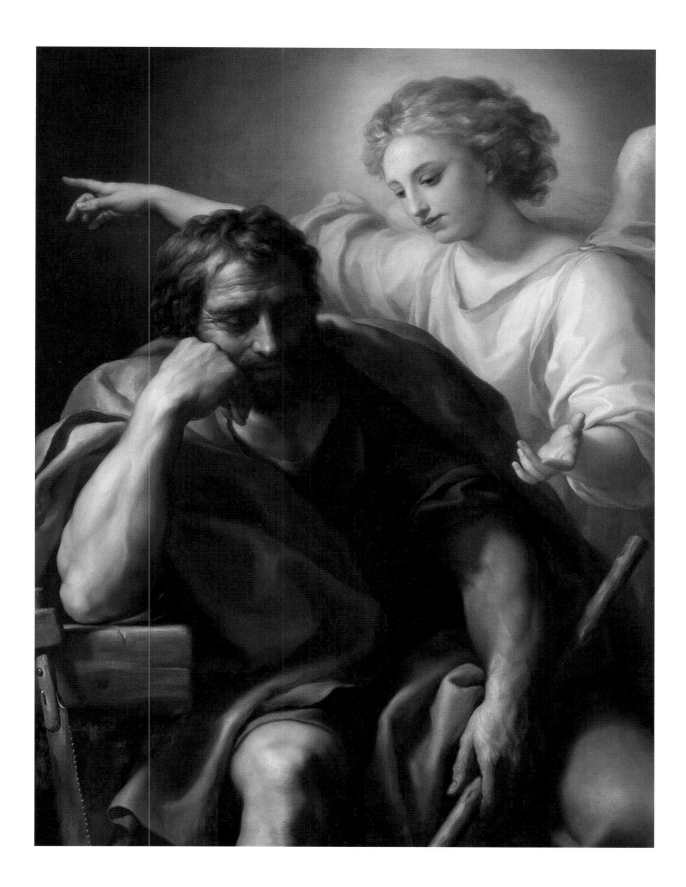

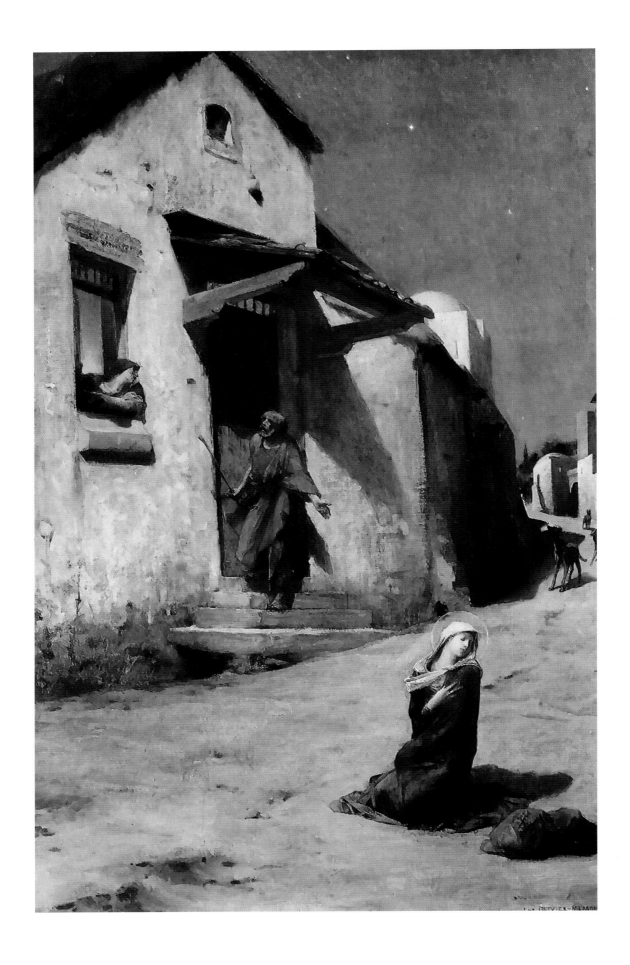

No Room in the Inn *Luke 2:1-7*

Now in those days, a decree went out from Caesar Augustus that all the world should be enrolled. This was the first enrollment made when Quirinius was governor of Syria. All went to enroll themselves, everyone to his own city. Joseph also went up from Galilee, out of the city of Nazareth, into Judea, to David's city, which is called Bethlehem, because he was of the house and family of David, to enroll himself with Mary, who was pledged to be married to him as wife, being pregnant.

While they were there, the day had come for her to give birth. She gave birth to her firstborn son. She wrapped Him in bands of cloth and laid Him in a feeding trough, because there was no room for them in the inn.

Luc-Olivier Merson 1846-1920

Merson was a French academic painter and illustrator also known for his postage stamp and currency designs. He also did the artwork for stained glass windows, an example of which can be found in the Church of the Holy Trinity at Rittenhouse Square in Philadelphia, Pennsylvania. Merson designed postage stamps for the French and Monaco post, and by 1908, he was contracted by the Bank of France to create several designs for some of the country's banknotes. Luc-Olivier Merson died in Paris in 1920, his work primarily forgotten due to the overwhelming popularity of the avant-garde art forms as seen in the works of the Impressionists and other artists' movements.

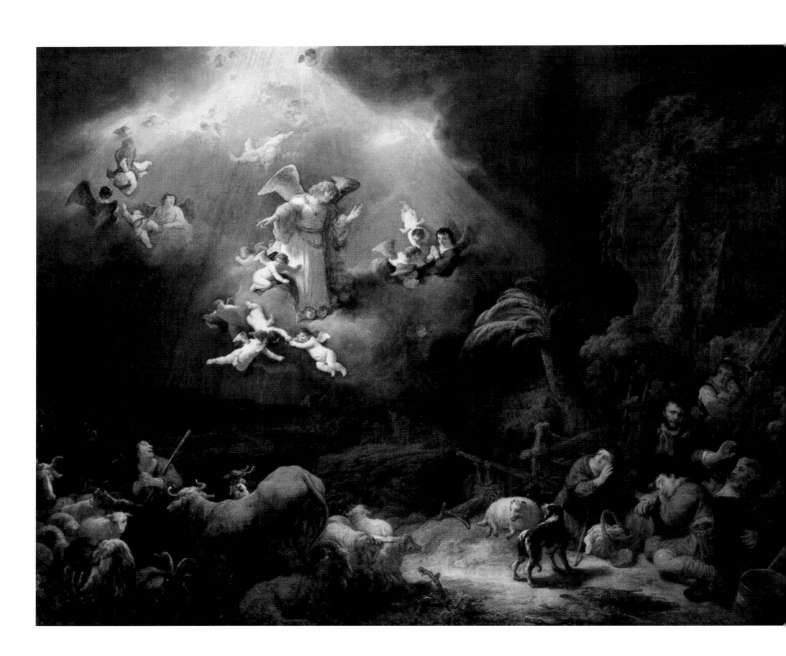

Angels Announcing the Birth of Christ to the Shepherds *Luke 2:8-15*

There were shepherds in the same country staying in the field, and keeping watch by night over their flock. Behold, an angel of the Lord stood by them, and the glory of the Lord shone around them, and they were terrified. The angel said to them, "Don't be afraid, for behold, I bring you good news of great joy which will be to all the people. For there is born to you today, in David's city, a Savior, who is Christ the Lord. This is the sign to you: you will find a baby wrapped in strips of cloth, lying in a feeding trough." Suddenly, there was with the angel a multitude of the heavenly army praising God and saying, "Glory to God in the highest, on earth peace, good will toward men."

Govert Flinck 1615-1660
Flinck was a Dutch painter of the Dutch Golden Age. His father apprenticed him to be a silk mercer, but having acquired a secret passion for etching and drawing, he was sent to Leeuwarden, where he boarded in the house of Lambert Jacobszoon. Here Flinck was joined by Jacob Backer, where the companionship of a youth determined like himself to be an artist only confirmed his passion for painting. Flinck labored on the lines of Rembrandt for many years; he followed Rembrandt's style in everything he created from 1636-1648. With aspirations as a history painter, however, he looked to the swelling forms and grand action of Peter Paul Rubens, which led to many commissions for official and diplomatic painting.

The Birth of Jesus Christ

For the census, the royal family has to travel eighty-five miles. Joseph walks, while Mary, nine months pregnant, rides sidesaddle on a donkey, feeling every jolt, every rut, every rock in the road.

By the time they arrive, the small hamlet of Bethlehem is swollen from an influx of travelers. The inn is packed, people feeling lucky if they were able to negotiate even a small space on the floor. Now it is late, everyone is asleep, and there is no room.

But fortunately, the innkeeper is not all shekels and mites. True, his stable is crowded with his guests' animals, but if they could squeeze out a little privacy there, they were welcome to it.

Joseph looks over at Mary, whose attention is concentrated on fighting a contraction. "We'll take it," he tells the innkeeper without hesitation.

The night is still when Joseph creaks open the stable door. As he does, a chorus of barn animals make discordant note of the intrusion. The stench is pungent and humid, as there have not been enough hours in the day to tend the guests, let alone the livestock. A small oil lamp, lent them by the innkeeper, flickers to dance shadows on the walls. A disquieting place for a woman in throes of childbirth. Far from home. Far from family. Far from what she had expected for her first born.

But Mary makes no complaint. It is a relief just to finally get off the donkey. She leans back against the wall, her feet swollen, back aching, contractions growing stronger and closer together.

Joseph's eyes dart around the stable. Not a minute to lose. Quickly. A feeding trough would have to make do for a crib. Hay would serve as a mattress. Blankets? Blankets? Ah, his robe. That would do. And those rags hung out to dry would help. A gripping contraction doubles Mary over and sends him racing for a bucket of water.

The birth would not be easy, either for the mother or the child. For every royal privilege for this son ended at conception.

A scream from Mary knifes through the calm of that silent night. Joseph returns, breathless, water sloshing from the wooden bucket. The top of the baby's head has already pushed its way into the world. Sweat pours from Mary's contorted face as Joseph, the most unlikely midwife in all Judea, rushes to her side.

The involuntary contractions are not enough and Mary has to push with all her strength, almost as if God were refusing to come into the world without her help.

Joseph places a garment beneath her, and with a final push and a long sigh her labor is over.

The Messiah has arrived.

Elongated head from the constricting journey through the birth canal. Light skin, as the pigment would take days or even weeks to surface. Mucus in his ears and nostrils. Wet and slippery from the amniotic fluid. The Son of the Most High God umbilically tied to a lowly Jewish girl.

The baby chokes and coughs. Joseph instinctively turns Him over and clears His throat.

Then He cries. Mary bares her breast and reaches over for the shivering baby. She lays Him on her chest, and His helpless cries subside. His tiny head bobs around on the unfamiliar terrain. This will be the first thing the infant king learns. Mary can feel His racing heartbeat as He gropes to nurse.

Deity nursing from a young maiden's breast. Could anything be more puzzling - or more profound?

Joseph sits exhausted, silent, full of wonder.

The baby finishes and sighs, the divine Word reduced to a few unintelligible sounds. Then, for the first time, His eyes fix on his mother's. Deity straining to focus. The Light of the World, squinting.

Tears pool in her eyes. She touches His tiny hand. Hands that once sculpted mountain ranges cling to her finger.

She looks up at Joseph, and through a watery veil, their souls touch. He crowds closer, cheek to cheek with his betrothed. Together they stare in awe at the baby Jesus, whose heavy eyelids begin to close. It has been a long journey. The King is tired.

And so, with barely a ripple of notice, God stepped into the warm lake of humanity. Without protocol and without pretention.

Where you would have expected angels, there were only flies. Where you would have expected heads of state, there were only donkeys, a few haltered cows, a nervous ball of sheep, a tethered camel, and a furtive scurry of curious barn mice.

Except for Joseph, there was no one to share Mary's pain. Or her joy. Yes, there were angels announcing the Savior's arrival - but only to a band of blue-collar shepherds. And yes, a magnificent star shone in the sky to mark His birthplace - but only three foreigners bothered to look up and follow it.

Thus, in the little town of Bethlehem... that one silent night... the royal birth of God's Son tiptoed quietly by... as the world slept.

Intimate Moments with the Savior by Ken Gire

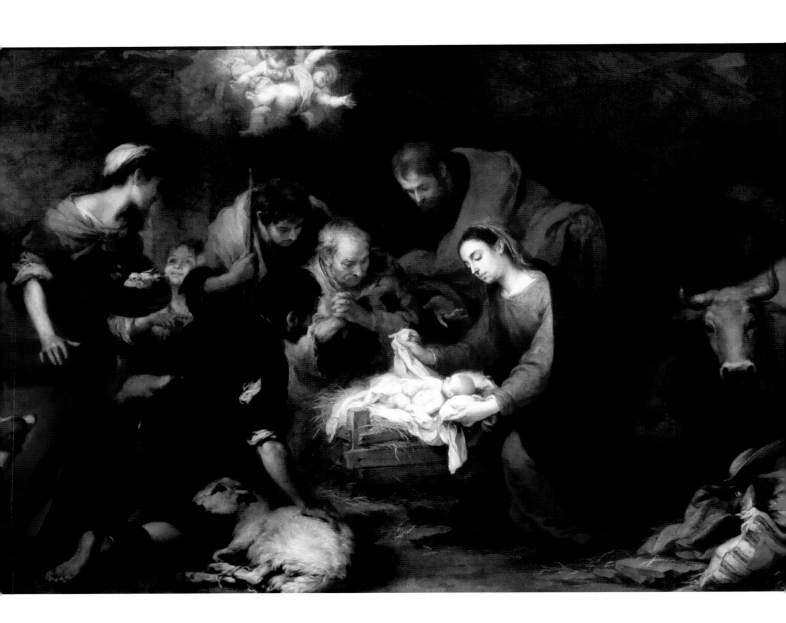

The Adoration of the Shepherds *Luke 2:15-20*

When the angels went away from them into the sky, the shepherds said to one another, "Let's go to Bethlehem, now, and see this thing that has happened, which the Lord has made known to us." They came with haste and found both Mary and Joseph, and the baby was lying in the feeding trough. When they saw it, they publicized widely the saying which was spoken to them about this child. All who heard it wondered at the things which were spoken to them by the shepherds. But Mary kept all these sayings, pondering them in her heart. The shepherds returned, glorifying and praising God for all the things that they had heard and seen, just as it was told them.

Bartolomè Murillo 1617-1682

Murillo was a Spanish Baroque artist. Although he is best known for his religious works, Murillo also produced many paintings of contemporary women and children. These lively, realistic portraits of flower girls, street urchins, and beggars constitute an extensive and appealing record of the everyday life of his times. In 1642, at the age of 26, he moved to Madrid, where he most likely became familiar with the work of Velázquez and would have seen the work of Venetian and Flemish masters in the royal collections; the rich colors and softly modeled forms of his subsequent work suggest these influences.

Presentation in the Temple *Luke 2:23-35*

When the days of their purification according to the law of Moses were fulfilled, they brought Him up to Jerusalem to present Him to the Lord (as it is written in the law of the Lord, "Every male who opens the womb shall be called holy to the Lord") and to offer a sacrifice according to that which is said in the law of the Lord, "A pair of turtledoves, or two young pigeons."

Behold, there was a man in Jerusalem whose name was Simeon. This man was righteous and devout, looking for the consolation of Israel, and the Holy Spirit was on him. It had been revealed to him by the Holy Spirit that he should not see death before he had seen the Lord's Christ. He came in the Spirit into the temple. When the parents brought in the child, Jesus, that they might do concerning Him according to the custom of the law, then he received Him into his arms and blessed God, and said, "Now you are releasing your servant, Master, according to your word, in peace; for my eyes have seen your salvation, which you have prepared before the face of all peoples; a light for revelation to the nations, and the glory of your people Israel."

Joseph and His mother were marveling at the things which were spoken concerning Him. Simeon blessed them, and said to Mary, His mother, "Behold, this Child is appointed for the falling and the rising of many in Israel, and for a sign which is spoken against. Yes, a sword will pierce through your own soul, that the thoughts of many hearts may be revealed."

Petr Brandl 1668-1735
The sixth child in a Czech-German family, Brandl was a Czech painter of the late Baroque in the bilingual Kingdom of Bohemia. Brandl was famous in his time but somewhat forgotten until recently due to the isolation behind the Iron Curtain. He employed strong chiaroscuro, areas of heavy impasto and very plastic, as well as dramatic figures. Brandl was apprenticed around 1683–1688 to Kristián Schröder (1655–1702). The National Gallery in Prague has an entire hall devoted to the artist's works, including *Bust of an Apostle* from some time before 1725.

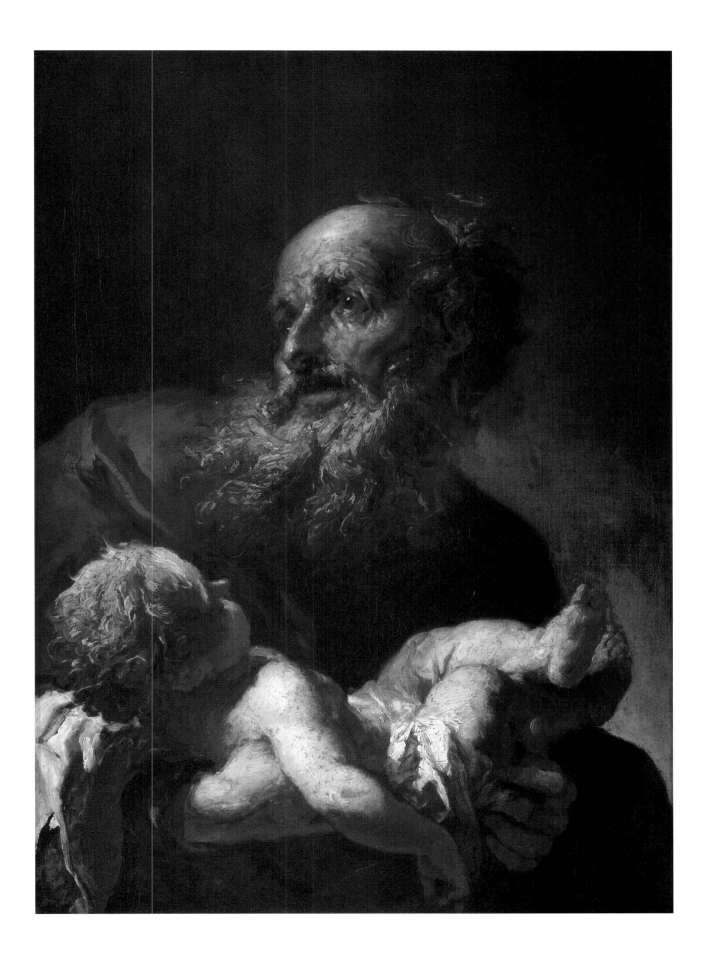

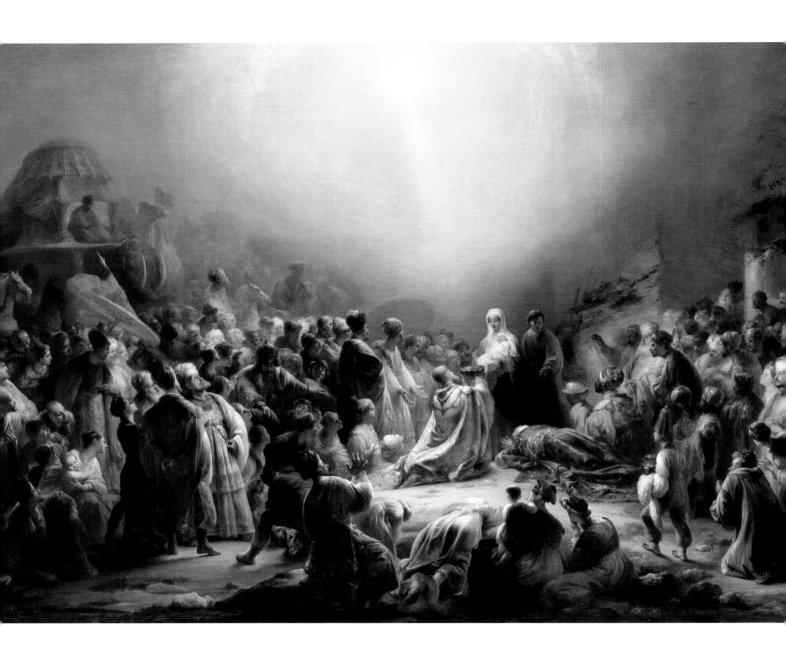

Domingos António de Sequeira 1768-1837

Sequeira was a famous Portuguese painter at the Royal Court of King John VI of Portugal. Born in Belém, Lisbon, into a modest family, he first studied art at the Academy of Lisbon before moving to Rome, where he was Antonio Cavallucci`s pupil. In 1795 he returned to his native country with such a great reputation that important commissions for churches and palaces were immediately entrusted to him. Sequeira spent the last years of his life in Rome, devoting himself chiefly to devotional subjects and his duties as head of the Portuguese Academy. A Turner exposition in the late 1820s served as inspiration for some of his best paintings, including *Visit of the Magi* (1828). Sequeira died in Rome in 1837.

Adoration of the Wise Men *Matthew 2:1-12*

Now when Jesus was born in Bethlehem of Judea in the days of King Herod, behold, wise men from the east came to Jerusalem, saying, "Where is He who is born King of the Jews? For we saw His star in the east, and have come to worship Him." When King Herod heard it, he was troubled, and all Jerusalem with him. Gathering together all the chief priests and scribes of the people, he asked them where the Christ would be born. They said to him, "In Bethlehem of Judea, for this is written through the prophet,

'You Bethlehem, land of Judah, are in no way least among the princes of Judah; for out of you shall come a governor who shall shepherd my people, Israel.' "

Then Herod secretly called the wise men, and learned from them exactly what time the star appeared. He sent them to Bethlehem, and said, "Go and search diligently for the young Child. When you have found Him, bring me word, so that I also may come and worship Him." They, having heard the king, went their way; and behold, the star, which they saw in the east, went before them until it came and stood over where the young Child was. When they saw the star, they rejoiced with exceedingly great joy. They came into the house and saw the young Child with Mary, His mother, and they fell down and worshiped Him. Opening their treasures, they offered to Him gifts: gold, frankincense, and myrrh. Being warned in a dream not to return to Herod, they went back to their own country another way.

Flight into Egypt *Matthew 2:13*

Now when they had departed, behold, an angel of the Lord

appeared to Joseph in a dream, saying, "Arise and take the young

Child and His mother, and flee into Egypt, and stay there until I

tell you, for Herod will seek the young Child to destroy Him."

Jacob Jordaens 1593-1678
Jordaens was a Flemish painter known for his history paintings, genre scenes, and portraits. He was one of the leading Flemish Baroque painters of his day. Unlike his contemporaries, Jordaens never traveled abroad to study Italian painting, and his career was marked by an indifference to their intellectual and courtly aspirations. In fact, except for a few short trips to locations in the Low Countries, he remained in Antwerp his entire life.

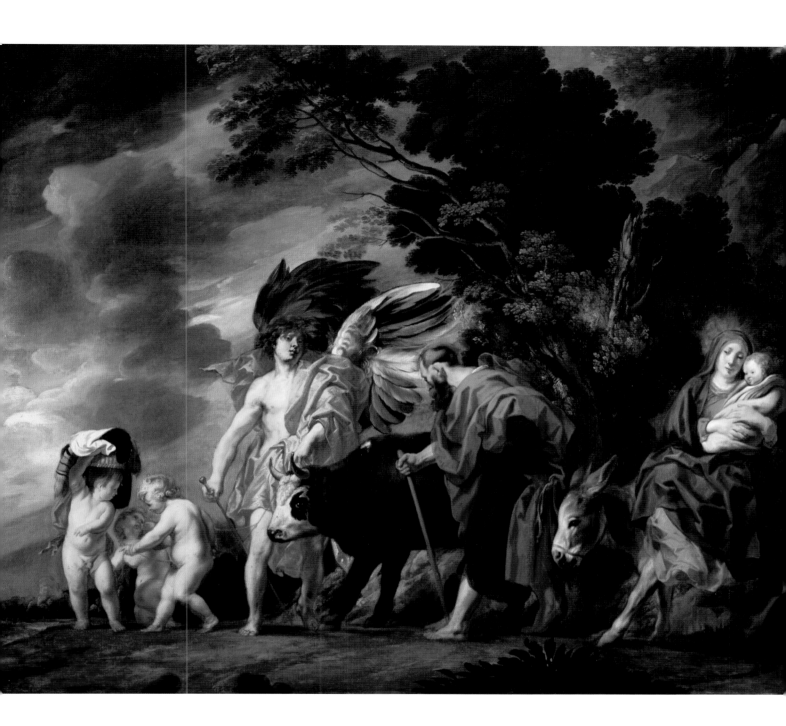

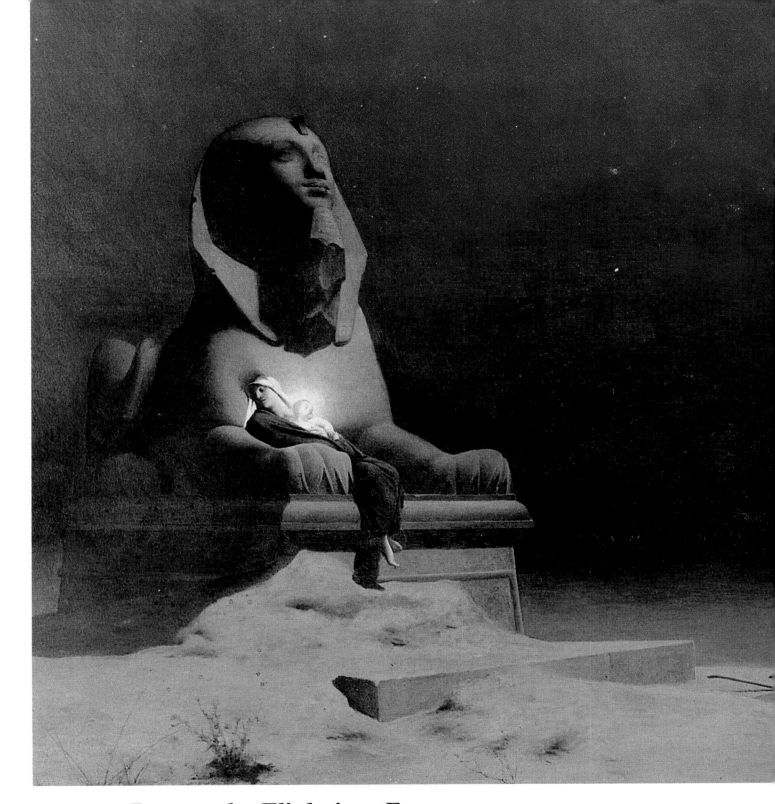

Rest on the Flight into Egypt *Matthew 2:14-15*

He arose and took the young Child and His mother by night and departed into Egypt, and was there until the death of Herod, that it might be fulfilled which was spoken by the Lord through the prophet, saying, "Out of Egypt I called My Son."

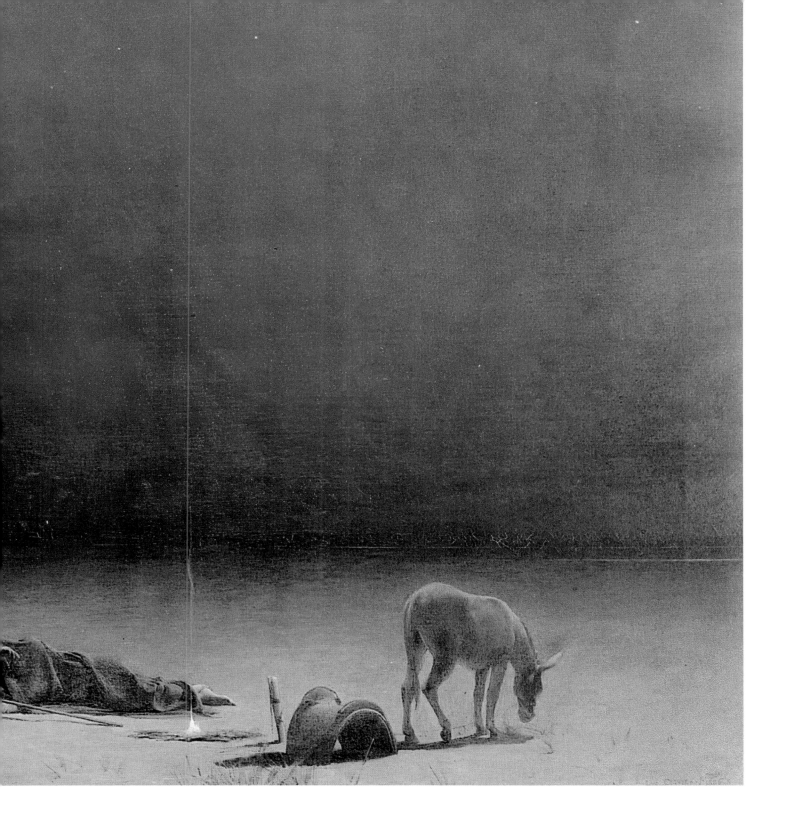

Luc-Olivier Merson 1846 -1920
Merson's career took the form of an interesting curve, with a very rapid ascent to the heights of the art world, followed immediately by a long, gradual decline that ended with his death in poverty, forgotten by the world. Above is the most famous painting from his time, *Rest on the Flight into Egypt* (1879).

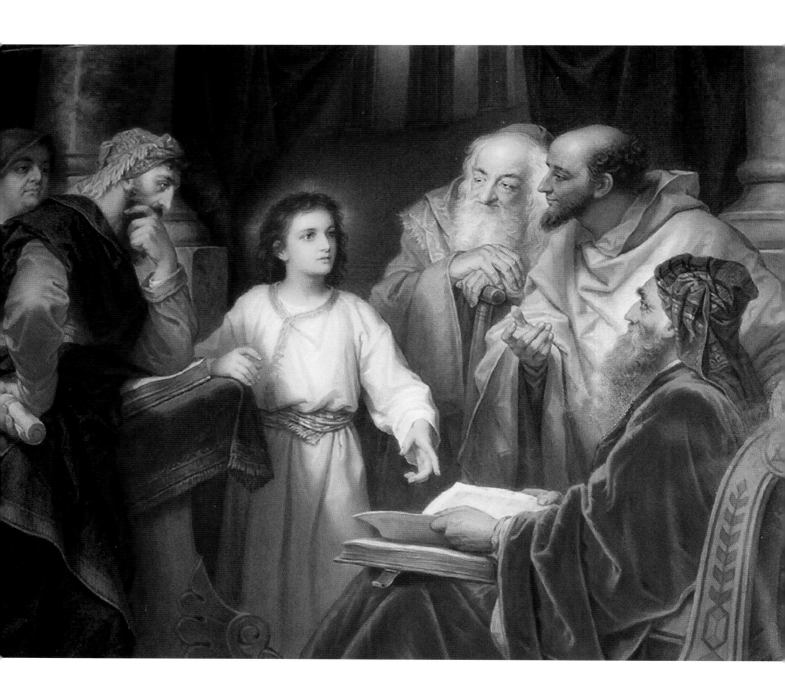

Heinrich Hofmann 1824-1911
Hofmann is best known for his many paintings depicting the life of Jesus Christ. Hofmann grew up in a family that harbored a deep interest in art. The religious body of Hofmann's work has gained in importance in the past years. One of the reasons for the increasing popularity of his artwork is the publication of his paintings and pencil drawings depicting the life of Jesus Christ in *The Second Coming of Christ*. Heinrich Hofmann was one of the pre-eminent painters of his time.

Visit to Jerusalem *Luke 2:41-52*

His parents went every year to Jerusalem at the feast of the Passover. When He was twelve years old, they went up to Jerusalem according to the custom of the feast; and when they had fulfilled the days, as they were returning, the boy Jesus stayed behind in Jerusalem. Joseph and His mother didn't know it, but supposing Him to be in the company, they went a day's journey; and they looked for Him among their relatives and acquaintances. When they didn't find Him, they returned to Jerusalem, looking for Him. After three days they found Him in the temple, sitting in the middle of the teachers, both listening to them and asking them questions. All who heard Him were amazed at His understanding and His answers. When they saw Him, they were astonished; and His mother said to Him, "Son, why have You treated us this way? Behold, Your father and I were anxiously looking for You."

He said to them, "Why were you looking for me? Didn't you know that I must be in My Father's house?" They didn't understand the saying which He spoke to them. And He went down with them and came to Nazareth. He was subject to them, and His mother kept all these sayings in her heart. And Jesus increased in wisdom and stature, and in favor with God and men.

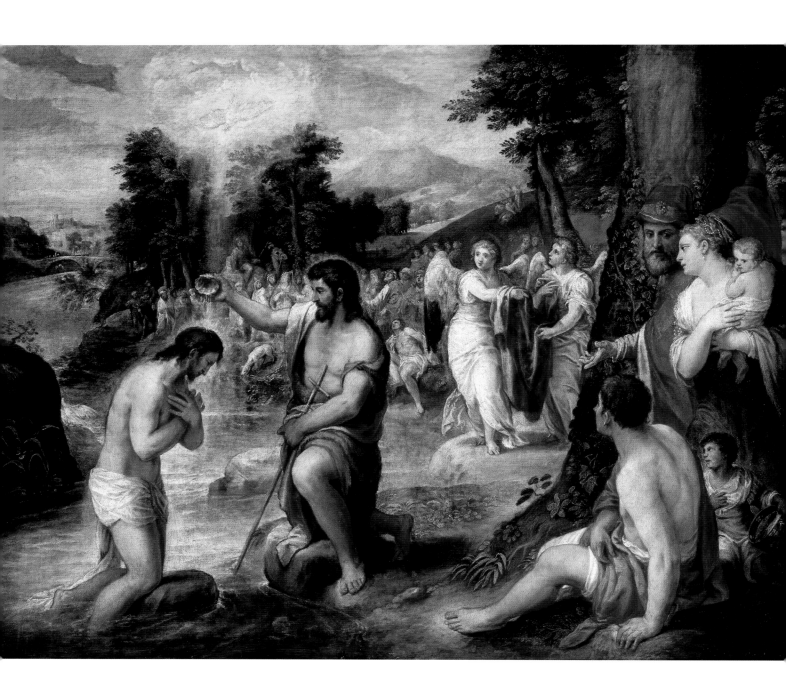

Christoph Schovarts 1540-1592

Schovarts was a German court painter. He took his information from Joachim von Sandrart, a German Baroque art historian and painter, active in Amsterdam during the Dutch Golden Age. According to him, Schovarts was born in Ingolstadt and made many frescos and oil paintings while serving Maximilian I, Elector of Bavaria. According to the Netherlands Institute for Art History, he died in 1592 and was the student of Johann Melchior Bocksberger, with whom he painted frescoes in Augsburg, and Wasserburg.

Jesus Baptized *Matthew 3:13-17*

Then Jesus came from Galilee to the Jordan to John, to be
baptized by him. But John would have hindered Him, saying,
"I need to be baptized by You, and You come to me? But Jesus,
answering, said to him, "Allow it now, for this is the fitting way for
us to fulfill all righteousness." Then he allowed Him. Jesus, when
He was baptized, went up directly from the water: and behold, the
heavens were opened to Him. He saw the Spirit of God descending
as a dove, and coming on Him. Behold, a voice out of the heavens
said, "This is My beloved Son, with whom I am well pleased."

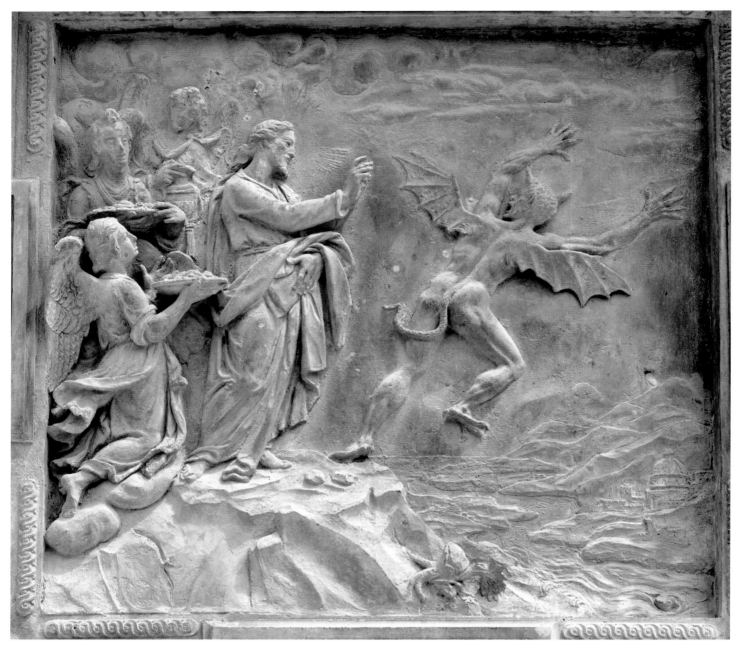

Christ in the Wilderness Tempted by the Devil. Bronze sculpture, door of Pisa Cathedral, school of Giambologna.

The Temptation of Jesus in the Wilderness

Luke 4:1-13

Jesus, full of the Holy Spirit, returned from the Jordan and was led by the Spirit into the wilderness for forty days, being tempted by the devil. He ate nothing in those days. Afterward, when they were completed, He was hungry. The devil said to Him, "If You are the Son of God, command this stone to become bread." Jesus answered him, saying, "It is written, 'Man shall not live by bread alone, but by every word of God.' "

The devil, leading Him up on a high mountain, showed Him all the kingdoms of the world in a moment of time. The devil said to Him, "I will give you all this authority and their glory, for it has been delivered to me, and I give it to whomever I want. If you therefore will worship before me, it will all be Yours." Jesus answered him, "Get behind me, Satan! For it is written, 'You shall worship the Lord your God, and you shall serve Him only.' "

He led Him to Jerusalem and set Him on the pinnacle of the temple, and said to Him, "If You are the Son of God, cast Yourself down from here, for it is written, 'He will put His angels in charge of You, to guard You'; and, 'On their hands they will bear You up, lest perhaps You dash Your foot against a stone.' " Jesus answering, said to him, "It has been said, 'You shall not tempt the Lord your God.' "

When the devil had completed every temptation, he departed from Him until another time.

The Wedding Feast at Cana *John 2:1-11*

On the third day there was a wedding in Cana of Galilee, and the mother of Jesus was there; and both Jesus and His disciples were invited to the wedding. When the wine ran out, the mother of Jesus said to Him, "They have no wine." And Jesus said to her, "Woman, what does that have to do with us? My hour has not yet come." His mother said to the servants, "Whatever He says to you, do it." Now there were six stone water pots set there for the Jewish custom of purification, containing twenty or thirty gallons each. Jesus said to them, "Fill the water pots with water." So they filled them up to the brim. And He said to them, "Draw some out now and take it to the headwaiter." So they took it to him. When the headwaiter tasted the water which had become wine, and did not know where it came from but the servants who had drawn the water knew, the headwaiter called the bridegroom, and said to him, "Every man serves the good wine first, and when the people have drunk freely, then he serves the poorer wine; but you have kept the good wine until now." This beginning of His signs Jesus did in Cana of Galilee, and manifested His glory, and His disciples believed in Him. After this He went down to Capernaum, He and His mother and His brothers and His disciples; and they stayed there a few days.

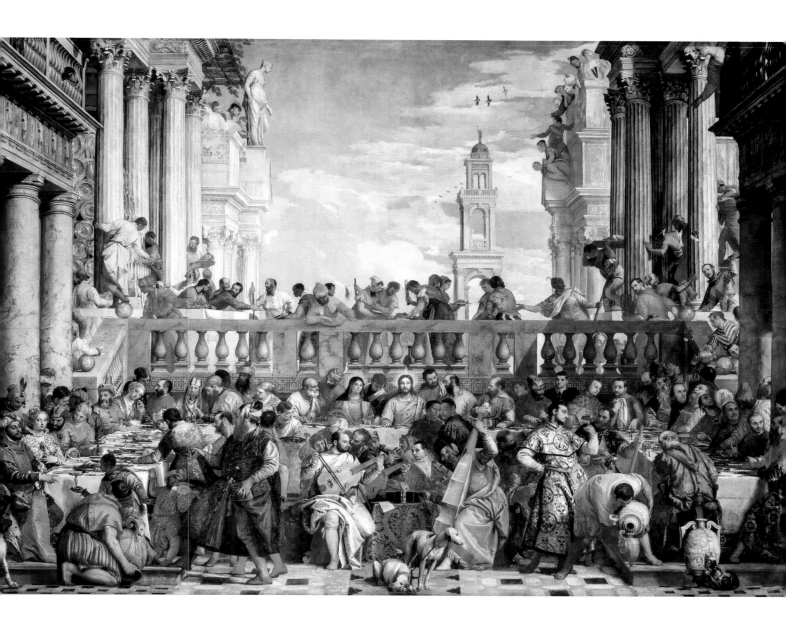

Paolo Veronese 1528-1588
Veronese was a late-Renaissance Mannerist Italian painter. His painting, *Wedding at Cana*, measures a colossal 21 ft. high and 32.5 ft. long and is displayed at the Louvre Museum in Paris. Veronese, along with Titian, at least a generation older, and Tintoretto, ten years older, was one of the great trio dominating Venetian paintings in the 16th century late Renaissance. Veronese is known as a supreme colorist and, after an early period with Mannerist influence, turned to a more naturalist style influenced by Titian.

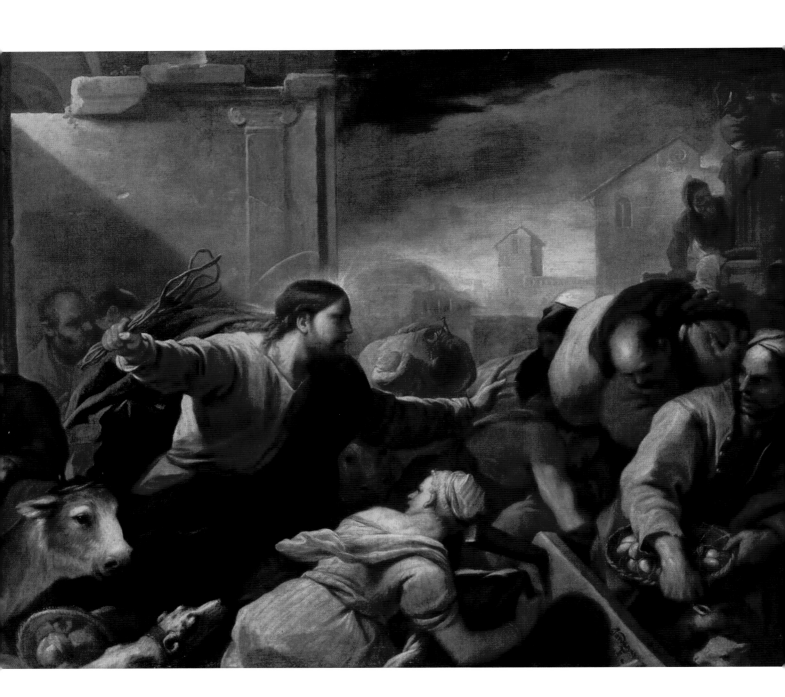

Expulsion of the Money Changers from the Temple

John 2:13-16

The Passover of the Jews was at hand, and Jesus went up to Jerusalem. He found in the temple those who sold oxen, sheep, and doves, and the changers of money sitting. He made a whip of cords and drove all out of the temple, both the sheep and the oxen; and He poured out the changers' money and overthrew their tables. To those who sold the doves, He said, "Take these things out of here! Don't make My Father's house a marketplace!" His disciples remembered that it was written, "Zeal for your house will eat Me up."

Luca Giordano 1634 -1705
Giordano was a late-Baroque Italian painter. Fluent and decorative, he worked successfully in Naples and Rome, Florence and Venice, before spending a decade in Spain. He acquired the nickname Luca fa presto, which translates into "Luca paints quickly." Following a period of studying in Rome, Parma, and Venice, Giordano developed an elaborate Baroque style, fusing Venetian and Roman influences. He is also noted for his lively and showy use of color.

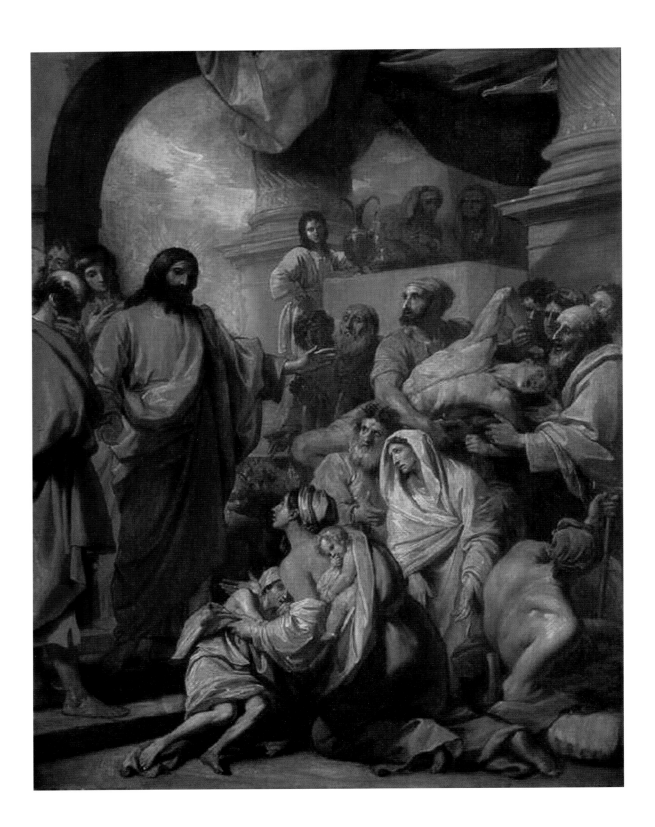

Christ Healing the Sick *Matthew 4:23-25*

Jesus went about in all Galilee, teaching in their synagogues,

preaching the Good News of the Kingdom, and healing every

disease and every sickness among the people. The report about Him

went out into all Syria. They brought to Him all who were sick,

afflicted with various diseases and torments, possessed with demons,

epileptics, and paralytics; and He healed them. Great multitudes

from Galilee, Decapolis, Jerusalem, Judea, and from beyond the

Jordan followed Him.

Benjamin West 1738-1820
West was a self-taught, American-born artist. Born in Springfield, Pennsylvania, in a house now in the borough of Swarthmore on the campus of Swarthmore College. He was the tenth child of an innkeeper. One day his mother left him alone with his little sister Sally. Benjamin discovered some bottles of ink and began to paint Sally's portrait. When his mother came home, she noticed the painting, picked it up, and said, "Why, it's Sally!" and kissed him. Later, he noted, "My mother's kiss made me a painter." West was a close friend of Benjamin Franklin, whose portrait he painted. Franklin was the godfather of West's second son, Benjamin.

Jesus and Nicodemus *John 3:1-21*

Now there was a man of the Pharisees named Nicodemus, a ruler of the Jews. He came to Jesus by night and said to Him, "Rabbi, we know that You are a teacher come from God, for no one can do these signs that You do, unless God is with Him." Jesus answered him, "Most certainly I tell you, unless one is born again, he can't see God's Kingdom."

Nicodemus said to Him, "How can a man be born when he is old? Can he enter a second time into his mother's womb and be born?" Jesus answered, "Most certainly I tell you, unless one is born of water and Spirit, he can't enter into God's Kingdom. That which is born of the flesh is flesh. That which is born of the Spirit is spirit. Don't marvel that I said to you, 'You must be born again.' The wind blows where it wants to, and you hear its sound, but don't know where it comes from and where it is going. So is everyone who is born of the Spirit." Nicodemus answered Him, "How can these things be? Jesus answered him, "Are you the teacher of Israel, and don't understand these things? Most certainly I tell you, we speak that which we know and testify of that which we have seen, and you don't receive our witness. If I told you earthly things and you don't believe, how will you believe if I tell you heavenly things? No one has ascended into heaven but He who descended out of heaven, the Son of Man, who is in heaven. As Moses lifted up the serpent in the wilderness, even so must the Son of Man be lifted up, that whoever believes in Him should not perish, but have eternal life.

For God so loved the world, that He gave His only born Son, that whoever believes in Him should not perish, but have eternal life. For God didn't send His Son into the world to judge the world, but that the world should be saved through Him. He who believes in Him is not judged. He who doesn't believe has been judged already, because he has not believed in the name of the only born Son of God. This is the judgment, that the Light has come into the world, and men loved the darkness rather than the Light, for their works were evil. For everyone who does evil hates the Light and doesn't come to the Light, lest his works would be exposed. But he who does the truth comes to the Light, that his works may be revealed, that they have been done in God."

John La Farge 1839-1910
La Farge was an American painter born in New York City. The son of prosperous French emigrants, La Farge was one of the first American artists to import and be influenced by Japanese color prints. One art critic wrote, "his striving to express shades of thought so delicate that they seem to render words almost useless." Between 1859 and 1870, he illustrated Tennyson's *Enoch Arden*.

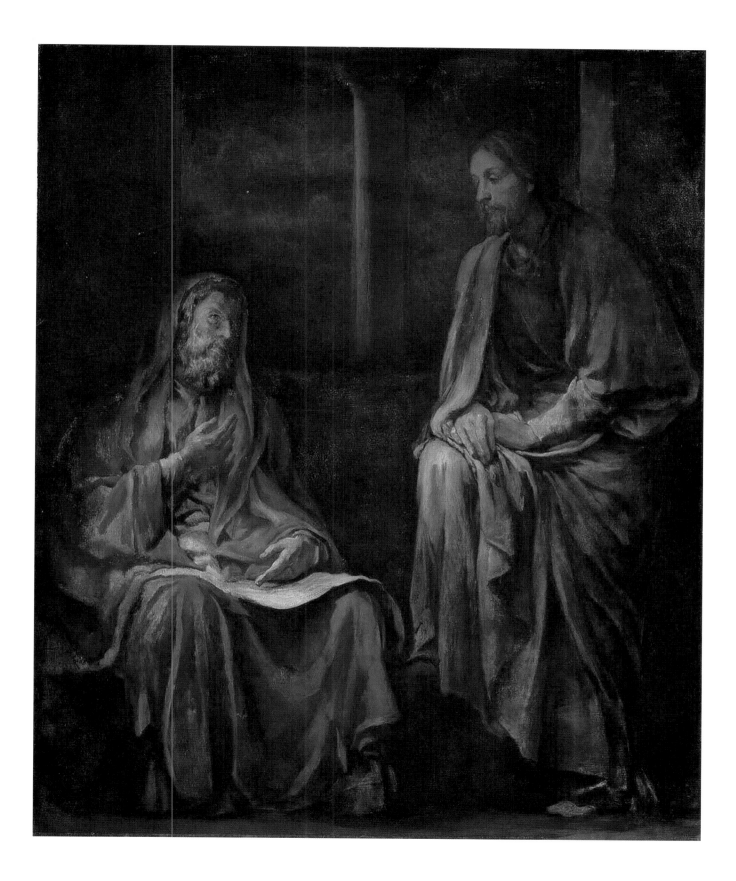

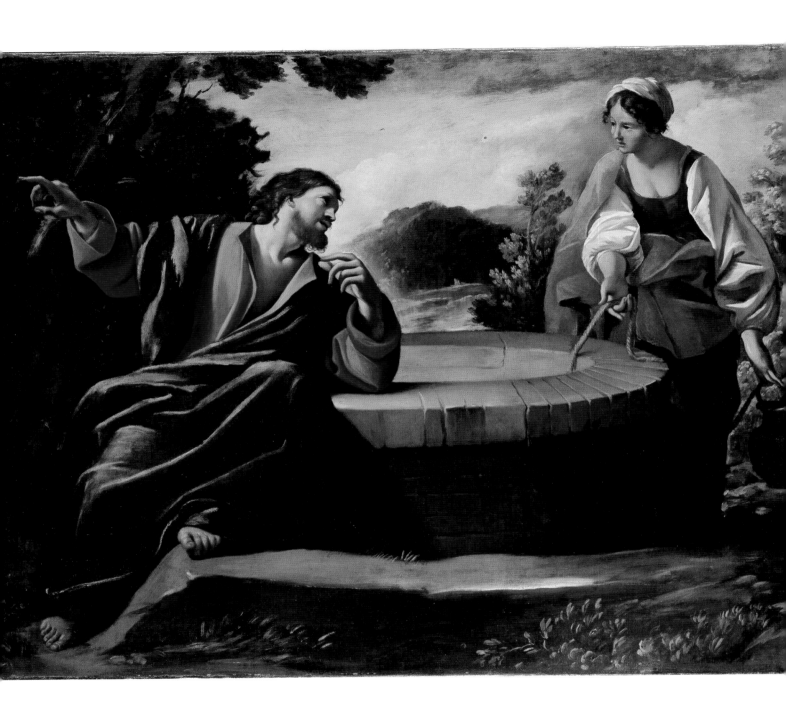

Giovanni Gaspare Lanfranco 1582-1647
Giovanni was an Italian painter of the Baroque period, born in Parma, Italy. His talent for drawing allowed him to begin an apprenticeship with the Bolognese artist Agostino Carracci, brother of Annibale Carracci. When Agostino died in 1602, both young artists moved to Annibale's large and prominent Roman workshop, working on the Galleria Farnese in the Palazzo Farnese gallery ceiling. Giovanni was a member of the Carracci studio. He explored new styles, bridged traditions, and painted in both mannerist and baroque styles using a tenebrist and the colorist palette. Among his pupils was Giacinto Brandi.

Jesus and the Samaritan Woman *John 4:7-30*

A woman of Samaria came to draw water. Jesus said to her, "Give Me a drink." For His disciples had gone away into the city to buy food. The Samaritan woman therefore said to Him, "How is it that You, being a Jew, ask for a drink from me, a Samaritan woman?" (For Jews have no dealings with Samaritans.) Jesus answered her, "If you knew the gift of God, and who it is who says to you, 'Give Me a drink,' you would have asked Him, and He would have given you living water." The woman said to Him, "Sir, You have nothing to draw with, and the well is deep. So where do You get that living water? Are You greater than our father Jacob, who gave us the well and drank from it himself, as did his children and his livestock?"

Jesus answered her, "Everyone who drinks of this water will thirst again, but whoever drinks of the water that I will give him will never thirst again; but the water that I will give him will become in him a well of water springing up to eternal life." The woman said to Him, "Sir, give me this water, so that I don't get thirsty, neither come all the way here to draw." Jesus said to her, "Go, call your husband, and come here." The woman answered, "I have no husband." Jesus said to her, "You said well, 'I have no husband,' for you have had five husbands; and he whom you now have is not your husband. This you have said truly." The woman said to Him, "Sir, I perceive that You are a prophet. Our fathers worshiped in this mountain, and you Jews say that in Jerusalem is the place where people ought to worship." Jesus said to her, "Woman, believe Me, the hour is coming when neither in this mountain nor in Jerusalem will you worship the Father. You worship that which you don't know. We worship that which we know; for salvation is from the Jews. But the hour comes, and now is, when the true worshipers will worship the Father in spirit and truth, for the Father seeks such to be His worshipers. God is spirit, and those who worship Him must worship in spirit and truth." The woman said to Him, "I know that Messiah is coming, He who is called Christ. When He has come, He will declare to us all things." Jesus said to her, "I am He, the one who speaks to you." Just then, His disciples came. They marveled that He was speaking with a woman; yet no one said, "What are You looking for?" or, "Why do You speak with her?" So the woman left her water pot, went away into the city, and said to the people, "Come, see a man who told me everything that I have done. Can this be the Christ?" They went out of the city, and were coming to Him.

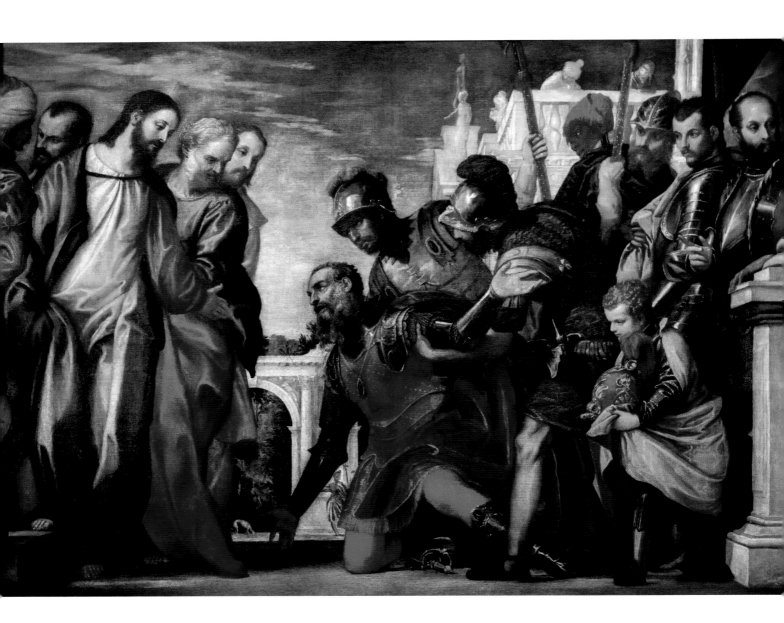

Miraculous Healing of the Nobleman's Son

John 4:46-53

Jesus came therefore again to Cana of Galilee, where He made the water into wine. There was a certain nobleman whose son was sick at Capernaum. When he heard that Jesus had come out of Judea into Galilee, he went to Him and begged Him that He would come down and heal his son, for he was at the point of death. Jesus therefore said to him, "Unless you see signs and wonders, you will in no way believe." The nobleman said to Him, "Sir, come down before my child dies." Jesus said to him, "Go your way. Your son lives." The man believed the word that Jesus spoke to him, and he went his way. As he was going down, his servants met him and reported, saying "Your child lives!" So he inquired of them the hour when he began to get better. They said therefore to him, "Yesterday at the seventh hour, the fever left him." So the father knew that it was at that hour in which Jesus said to him, "Your son lives." He believed, as did his whole house.

Paolo Veronese 1528-1588

Paolo was born in Verona – hence his nickname 'Veronese'. He moved to Venice in the early 1550s and stayed there for the rest of his life, becoming one of the leading painters of the 16th century. Veronese was trained by Antonio Badile (about 1518–1560), whose daughter he married in 1566. In Venice, Titian's approach to composition, narrative, and coloring was crucial for Veronese. Yet, his work is characterized by principles of harmony and compositional cohesion that owe as much to Raphael and the Central Italian tradition as to the Venetian. The flowing, sinuous line of Parmigianino is also an important precedent. Giulio Romano and his Venetian colleague and rival Tintoretto were also significant touchstones at various points of Veronese's career. Still, his outlook is ultimately classical and harmonious in a way we tend not to associate with their work, and what has come more broadly understood as Mannerism. Veronese worked for patrons, religious and secular, in Venice and the Veneto for most of his career.

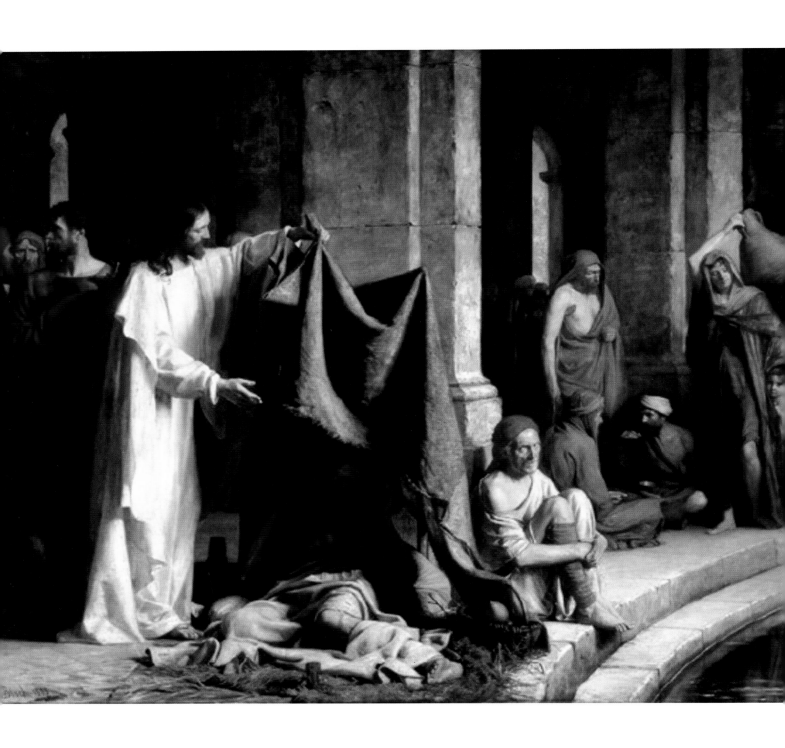

Carl Heinrich Bloch 1834-1890
Bloch was a Danish painter born in Copenhagen, Denmark. He was commissioned to produce 23 paintings for the Chapel at Frederiksborg Palace. These were all scenes from the life of Christ, which have become very popular as illustrations. The originals, painted between 1865 and 1879, are still at Frederiksborg Palace.

Miracle at the Pool of Bethesda *John 5:1-17*

After these things, there was a feast of the Jews, and Jesus went up to Jerusalem.

Now in Jerusalem by the sheep gate, there is a pool, which is called in Hebrew, Bethesda, having five porches. In these lay a great multitude of those who were sick, blind, lame, or paralyzed, waiting for the moving of the water; for an angel went down at certain times into the pool and stirred up the water. Whoever stepped in first after the stirring of the water was healed of whatever disease he had. A certain man was there who had been sick for thirty-eight years. When Jesus saw him lying there, and knew that he had been sick for a long time, he asked him, "Do you want to be made well?" The sick man answered Him, "Sir, I have no one to put me into the pool when the water is stirred up, but while I'm coming, another steps down before me." Jesus said to him, "Arise, take up your mat, and walk." Immediately, the man was made well, and took up his mat and walked.

Now that day was a Sabbath. So the Jews said to him who was cured, "It is the Sabbath. It is not lawful for you to carry the mat." He answered them, "He who made me well said to me, 'Take up your mat and walk.'" Then they asked him, "Who is the man who said to you, 'Take up your mat and walk'?" But he who was healed didn't know who it was, for Jesus had withdrawn, a crowd being in the place. Afterward Jesus found him in the temple and said to him, "Behold, you are made well. Sin no more, so that nothing worse happens to you." The man went away, and told the Jews that it was Jesus who had made him well. For this cause the Jews persecuted Jesus and sought to kill Him, because He did these things on the Sabbath. But Jesus answered them, "My Father is still working, so I am working, too."

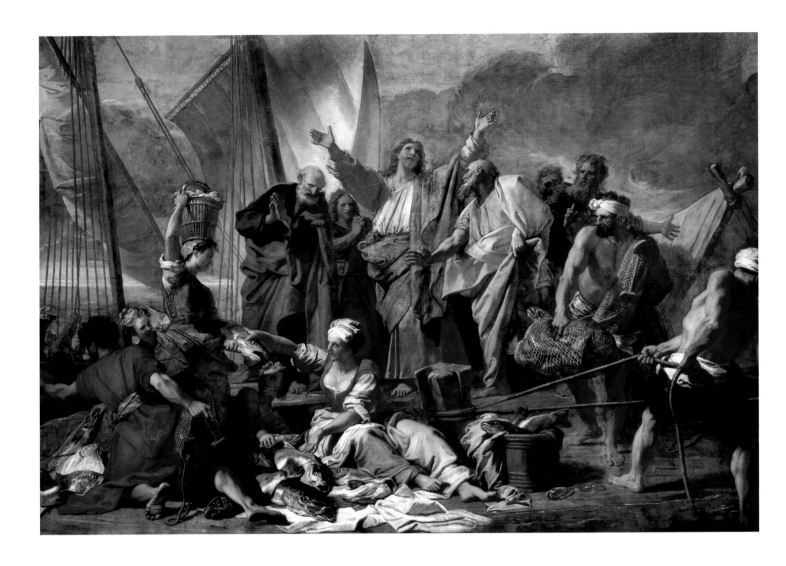

Jean-Baptiste Jouvenet 1644-1717
Jouvenet showed a remarkable aptitude for his profession at a young age. When he arrived in Paris, he attracted the attention of Le Brun and was employed at Versailles. He became a member of the Académie Royale and was elected professor in 1681. Jouvenet executed a great mass of works, mainly in Paris, demonstrating his fertility in invention and execution. His celebrated *Miraculous Draught of Fishes*, among others, now hangs in the Louvre. He was distinguished by a general dignity of arrangement and style. Jouvenet's compositions are primarily planned as high reliefs and the movements are in sharp diagonal straight lines rather than in curves. The naturalism of his style sets his work apart from most of the religious paintings of his time.

The First Disciples *Luke 5:1-11*

The Miraculous Draught of Fishes

Now while the multitude pressed on Him and heard the word of God, He was standing by the lake of Gennesaret. He saw two boats standing by the lake, but the fishermen had gone out of them and were washing their nets. He entered into one of the boats, which was Simon's, and asked him to put out a little from the land. He sat down and taught the multitudes from the boat. When He had finished speaking, He said to Simon, "Put out into the deep and let down your nets for a catch." Simon answered Him, "Master, we worked all night and caught nothing; but at your word I will let down the net." When they had done this, they caught a great multitude of fish, and their net was breaking. They beckoned to their partners in the other boat, that they should come and help them. They came and filled both boats, so that they began to sink. But Simon Peter, when he saw it, fell down at Jesus' knees, saying, "Depart from me, for I am a sinful man, Lord." For he was amazed, and all who were with him, at the catch of fish which they had caught; and so also were James and John, sons of Zebedee, who were partners with Simon. Jesus said to Simon, "Don't be afraid. From now on you will be catching men." When they had brought their boats to land, they left everything, and followed Him.

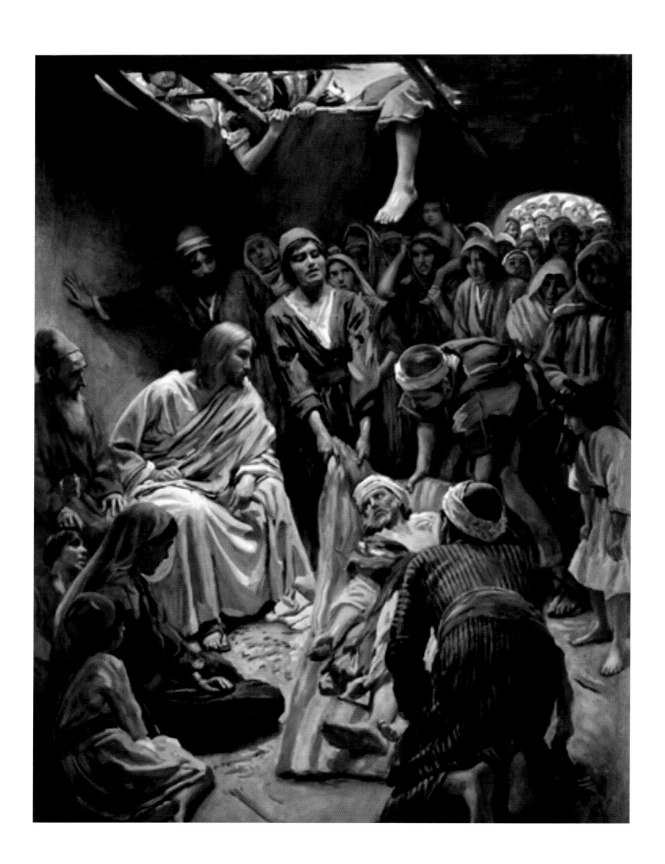

Jesus Heals the Paralytic *Luke 5:17-26*

On one of those days, He was teaching; and there were Pharisees and teachers of the law sitting by who had come out of every village of Galilee, Judea, and Jerusalem. The power of the Lord was with Him to heal them. Behold, men brought a paralyzed man on a cot, and they sought to bring him in to lay before Jesus. Not finding a way to bring him in because of the multitude, they went up to the housetop and let him down through the tiles with his cot into the middle before Jesus. Seeing their faith, He said to him, "Man, your sins are forgiven you." The scribes and the Pharisees began to reason, saying, "Who is this Who speaks blasphemies? Who can forgive sins, but God alone?" But Jesus, perceiving their thoughts, answered them, "Why are you reasoning so in your hearts? Which is easier to say, 'Your sins are forgiven you,' or to say, 'Arise and walk?' But that you may know that the Son of Man has authority on earth to forgive sins," He said to the paralyzed man, "I tell you, arise, take up your cot, and go to your house." Immediately he rose up before them, and took up that which he was laying on, and departed to his house, glorifying God. Amazement took hold on all, and they glorified God. They were filled with fear, saying, "We have seen strange things today."

Harold Copping 1863-1932
Copping was born in 1863, Camden Town, London, England. After studying at the Royal Academy School, he visited Paris on a Landseer Scholarship and became an accomplished illustrator. His early books included *Hammond's Hard Lines* (1894), *Miss Bobbie* (1897), *Millionaire* (1898), *A Queen Among Girls* (1900), *Pilgrim's Progress* (1903), *Westward Ho!* (1903), *Grace Abounding* (1905), *Three School Chums* (1907), *Children's Stories from Dickens* (1911), *Little Women* (1912), *Good Wives* (1913), and *A Christmas Carol* (1920). Copping was best known as an illustrator of Biblical scenes. His 1910 book *The Copping Bible* illustrated by himself became a best-seller. Copping's most famous Bible illustration is likely *The Hope of the World* (1915).

Sermon on the Mount *Matthew 5:1-12*

Seeing the multitudes, He went up onto the mountain. When He had sat down,

His disciples came to Him. He opened His mouth and taught them, saying,

"Blessed are the poor in spirit,

for theirs is the Kingdom of Heaven.

Blessed are those who mourn,

for they shall be comforted.

Blessed are the gentle, for they shall inherit the earth.

Blessed are those who hunger and thirst for righteousness, for they shall be filled.

Blessed are the merciful, for they shall obtain mercy.

Blessed are the pure in heart, for they shall see God.

Blessed are the peacemakers, for they shall be called children of God.

Blessed are those who have been persecuted for righteousness' sake, for theirs is the

Kingdom of Heaven.

"Blessed are you when people reproach you, persecute you, and say all kinds of evil

against you falsely, for my sake. Rejoice, and be exceedingly glad, for great is your

reward in heaven. For that is how they persecuted the prophets who were before you."

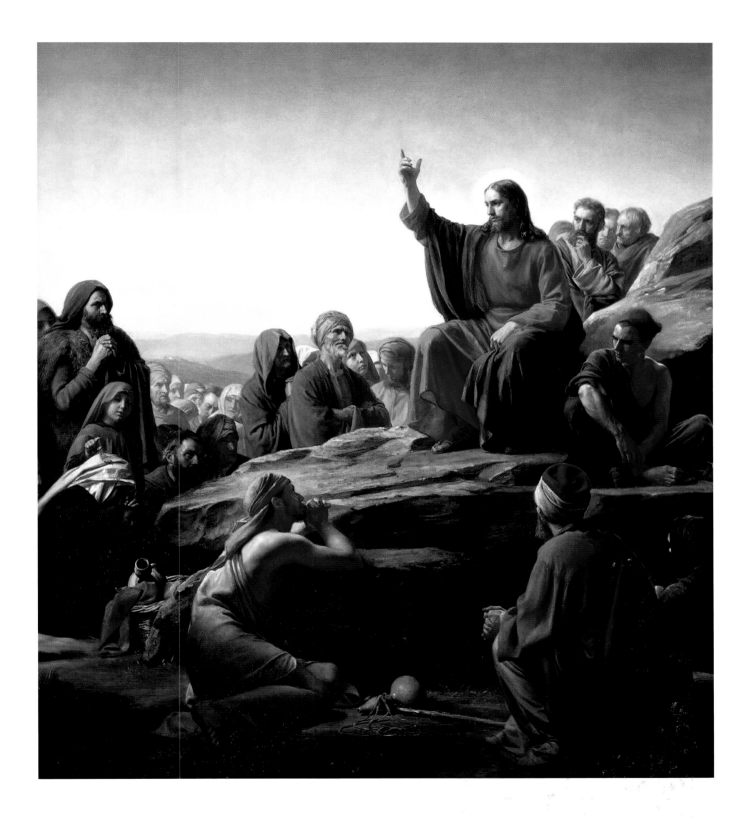

Carl Heinrich Bloch 1834-1890
While in Rome, Bloch met his wife, Alma Trepka. They were married on May 31, 1868. They were happily married until her early death in 1886. The sorrow over losing his wife weighed heavily on Bloch and being left alone with their eight children after her death was very difficult for him.

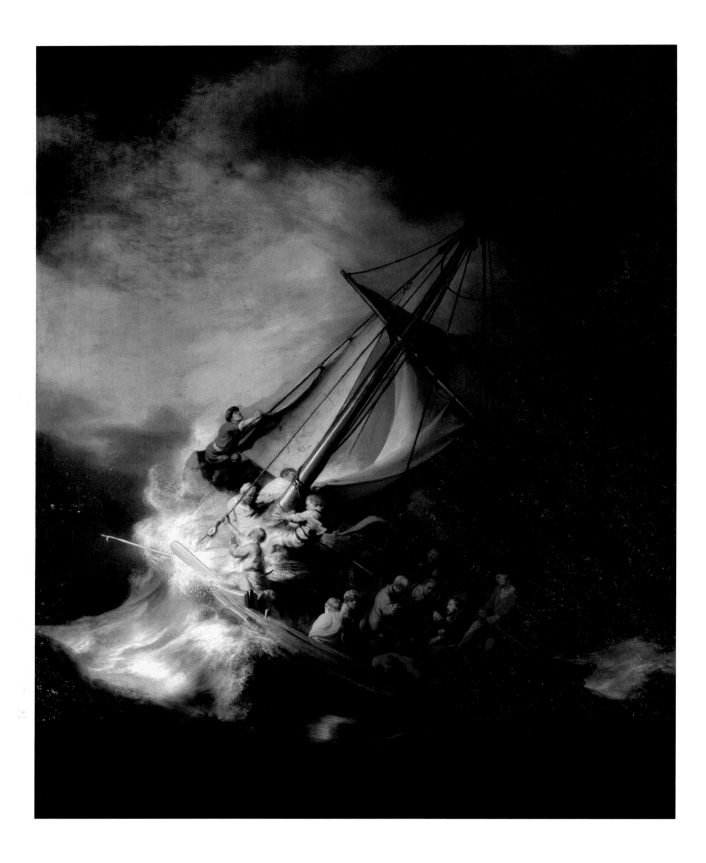

Christt Calms the Storm *Luke 8:22-25*

Now on one of those days, He entered into a boat, Himself

and His disciples, and He said to them, "Let's go over to the

other side of the lake." So they launched out. But as they sailed,

He fell asleep. A wind storm came down on the lake, and they

were taking on dangerous amounts of water. They came to Him

and awoke Him, saying, "Master, Master, we are dying!" He

awoke and rebuked the wind and the raging of the water; then

they ceased, and it was calm. He said to them, "Where is your

faith?" Being afraid, they marveled, saying to one another,

"Who is this then, that He commands even the winds and the

water, and they obey Him?"

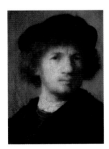

Rembrandt 1606-1669
Only one figure looks directly out at us as he steadies himself by grasping a rope and holds onto his cap. On the morning of March 18, 1990, thieves disguised as police officers broke into Isabella Stewart Gardner Museum in Boston, Massachusetts, and stole *The Storm on the Sea of Galilee* and 12 other works. It is considered the most significant art theft in US history and remains unsolved. The Museum still displays the paintings empty frames in their original locations.

Jairus' Daughter *Matthew 9:18-24*

While He was still speaking, people came from the synagogue ruler's house, saying, "Your daughter is dead. Why bother the Teacher any more?" But Jesus, when He heard the message spoken, immediately said to the ruler of the synagogue, "Don't be afraid, only believe." He allowed no one to follow Him except Peter, James, and John the brother of James. He came to the synagogue ruler's house, and He saw an uproar, weeping, and great wailing. When He had entered in, He said to them, "Why do you make an uproar and weep? The child is not dead, but is asleep." They ridiculed Him. But He, having put them all out, took the father of the child, her mother, and those who were with Him, and went in where the child was lying. Taking the child by the hand, He said to her, "Talitha cumi!" which means, being interpreted, "Girl, I tell you, get up!" Immediately the girl rose up and walked, for she was twelve years old. They were amazed with great amazement. He strictly ordered them that no one should know this, and commanded that something should be given to her to eat.

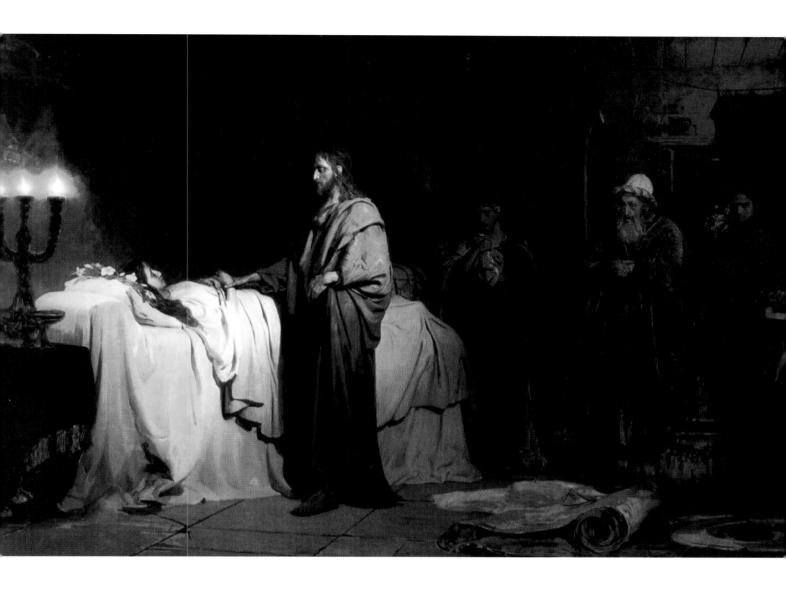

Ilya Repin 1844-1930
Repin was the most renowned Ukrainian Russian realist artist of the 19th century, his position in the world of art was comparable to that of Leo Tolstoy in literature. He played a significant role in bringing Russian art into the mainstream of European culture and persistently searched for new techniques and content to give his work more fullness and depth. His method was the reverse of impressionism. He produced works slowly and carefully; they were the result of close and detailed study. With some of his paintings, he made one hundred or more preliminary sketches. He was never satisfied with his works, and often painted multiple versions, years apart. He constantly changed and adjusted his methods to obtain more effective arrangement, grouping, and coloristic power.

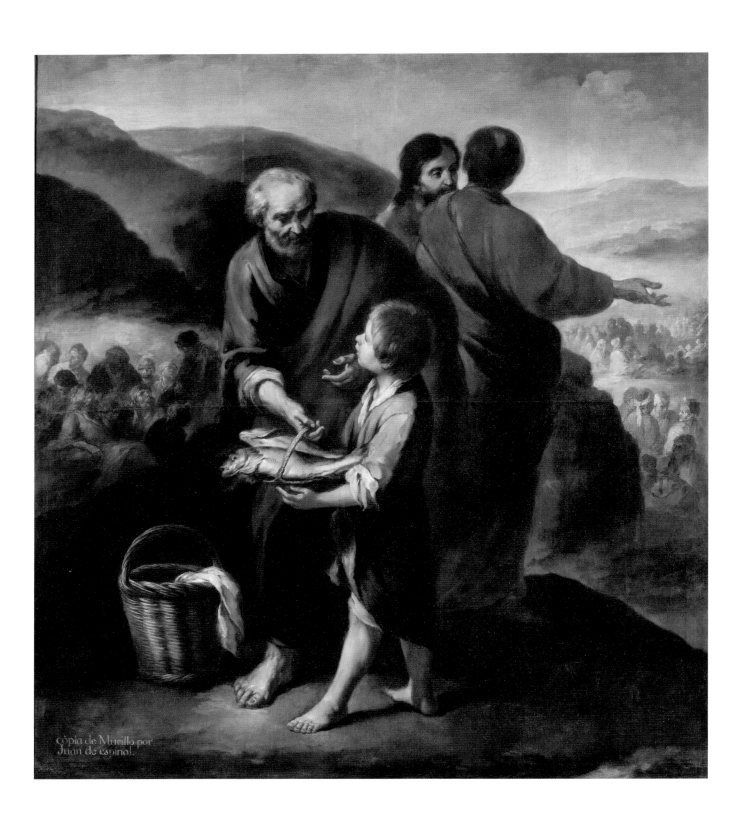

copia de Murillo por
Juan de espinal.

Jesus Feeds the Five Thousand *Mark 8:1-9*

In those days, when there was a very great multitude, and they had nothing to eat, Jesus called His disciples to Himself and said to them, "I have compassion on the multitude, because they have stayed with Me now three days and have nothing to eat. If I send them away fasting to their home, they will faint on the way, for some of them have come a long way." His disciples answered Him, "From where could one satisfy these people with bread here in a deserted place?" He asked them, "How many loaves do you have?" They said, "Seven." He commanded the multitude to sit down on the ground, and He took the seven loaves. Having given thanks, He broke them and gave them to His disciples to serve, and they served the multitude. They also had a few small fish. Having blessed them, He said to serve these also. They ate and were filled. They took up seven baskets of broken pieces that were left over. Those who had eaten were about four thousand. Then He sent them away.

Juan de Espinal 1714-1783
A native of Seville, Juan de Espinal was a Spanish historical painter. He was the son and pupil of Gregorio Espinal, who was also a painter; he later entered the school of Domingo Martinez, whose daughter he married. He was chosen director of the School of Design, which Cean Bermudez and other art lovers established at Seville. Cean Bermudez said Espinal possessed more genius than any of his contemporaries. But for his inadequate training and laziness, he would have been the best painter whom Seville had produced since the time of Murillo. A visit to Madrid late in life made apparent his misspent time, and he returned saddened and abashed to Seville, where he died in 1783. His chief works were scenes from the life of St. Jerome, painted for the monastery of San Geronimo de Buenavista and now in the Seville Museum, and some frescoes in the collegiate church of San Salvador.

Jesus Walks on the Water *Mark 6:45-52*

Immediately He made His disciples get into the boat and go ahead to the other side, to Bethsaida, while He Himself sent the multitude away. After He had taken leave of them, He went up the mountain to pray.

When evening had come, the boat was in the middle of the sea, and He was alone on the land. Seeing them distressed in rowing, for the wind was contrary to them, about the fourth watch of the night He came to them, walking on the sea; and He would have passed by them, but they, when they saw Him walking on the sea, supposed that it was a ghost, and cried out; for they all saw Him and were troubled. But He immediately spoke with them and said to them, "Cheer up! It is I! Don't be afraid." He got into the boat with them; and the wind ceased, and they were very amazed among themselves, and marveled; for they hadn't understood about the loaves, but their hearts were hardened.

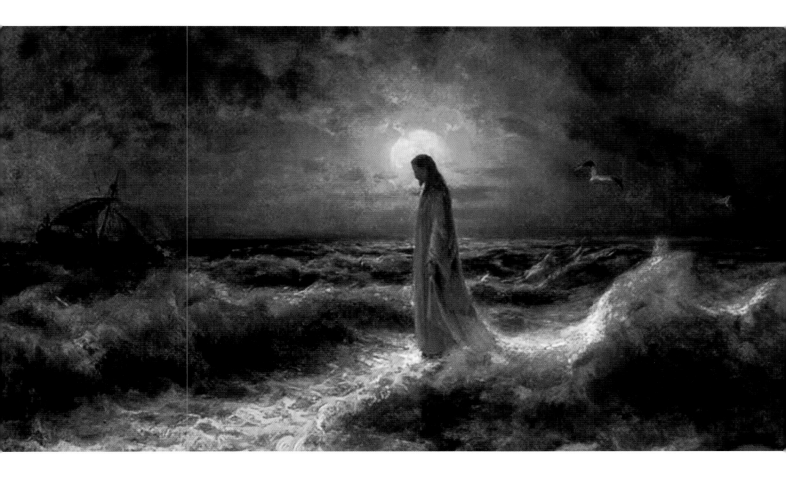

Julius Sergius von Klever 1850-1924
Born in Saint Petersburg, von Klever was a Baltic German landscape painter. He displayed artistic talent at an early age and took lessons from Konstantin von Kügelgen. After completing his primary education, von Klever was enrolled at the Imperial Academy of Fine Arts St. Petersburg at his father's insistence. After a short time, he began to take landscape painting classes, first with Sokrat Vorobiev, then Mikhail Clodt. In 1870, he was expelled from the Academy for unknown reasons. Undeterred, he started exhibiting his works. In 1871, one was purchased by Count Pavel Stroganov and, the following year, his painting Sunset was acquired by Grand Duchess Maria Nikolaevna. In 1874, von Klever had his first solo exhibition at the Imperial Society for the Encouragement of the Arts. After Tsar Alexander II expressed interest in his work, he was named an "Artist" by the Academy, despite having not graduated. In 1878, he became an Academician.

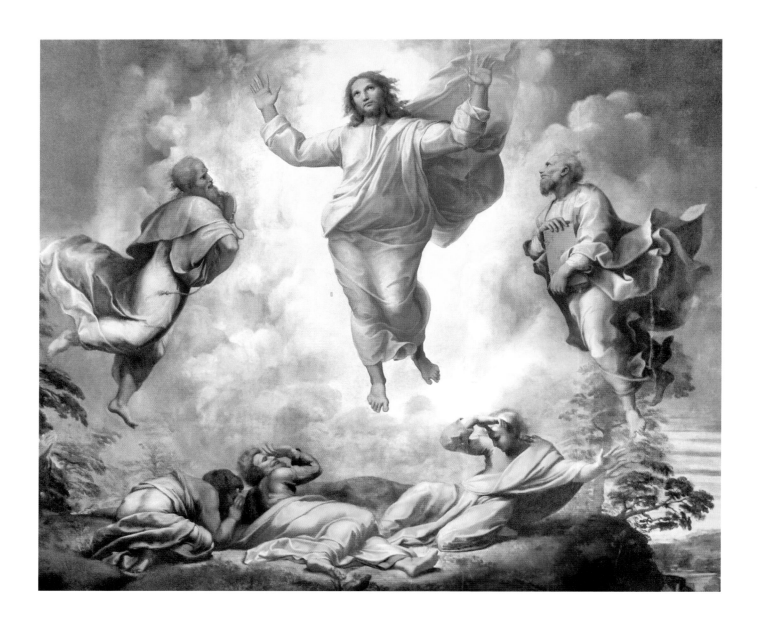

Raphael 1483-1520

Born Raffaello Sanzio, Raphael was an Italian painter and architect of the High Renaissance. After studying first with his father, a painter in the court at Urbino, Raphael became Perugino's apprentice in 1504. Leaving his apprenticeship, he moved to Florence, where he was heavily influenced by the works of the Italian painters Bartolommeo, Leonardo da Vinci, and Michelangelo. To Raphael, these innovative artists achieved a whole new level of depth in their composition. By closely studying the details of their work, Raphael managed to develop an even more intricate and expressive personal style than was evident in his earlier paintings. Raphael died suddenly on April 6, 1520, of mysterious causes. He had been working on *The Transfiguration*, his largest painting on canvas, at the time of his death. Raphael's funeral mass was held at the Vatican and the unfinished *Transfiguration* was placed on his coffin stand.

The Transfiguration *Matthew 17:1-8*

After six days, Jesus took with Him Peter, James, and John his brother, and brought them up into a high mountain by themselves. He was changed before them. His face shone like the sun, and His garments became as white as the light. Behold, Moses and Elijah appeared to them talking with Him. Peter answered and said to Jesus, "Lord, it is good for us to be here. If You want, let's make three tents here: one for You, one for Moses, and one for Elijah." While he was still speaking, behold, a bright cloud overshadowed them. Behold, a voice came out of the cloud, saying, "This is my beloved Son, in whom I am well pleased. Listen to Him."

When the disciples heard it, they fell on their faces, and were very afraid. Jesus came and touched them and said, "Get up, and don't be afraid." Lifting up their eyes, they saw no one, except Jesus alone.

As they were coming down from the mountain, Jesus commanded them, saying, "Don't tell anyone what you saw, until the Son of Man has risen from the dead."

The Adulteress *John 8:2-11*

Now very early in the morning, He came again into the temple, and all the people came to Him. He sat down and taught them. The scribes and the Pharisees brought a woman taken in adultery. Having set her in the middle, they told Him, "Teacher, we found this woman in adultery, in the very act. Now in our law, Moses commanded us to stone such women. What then do You say about her?" They said this testing Him, that they might have something to accuse Him of. But Jesus stooped down and wrote on the ground with His finger. But when they continued asking him, He looked up and said to them, "He who is without sin among you, let him throw the first stone at her." Again He stooped down and wrote on the ground with His finger. When they heard it, being convicted by their conscience, went out one by one, beginning from the oldest, even to the last. Jesus was left alone with the woman where she was, in the middle. Jesus, standing up, saw her and said, "Woman, where are your accusers? Did no one condemn you?" She said, "No one, Lord." Jesus said, "Neither do I condemn you. Go your way. From now on, sin no more."

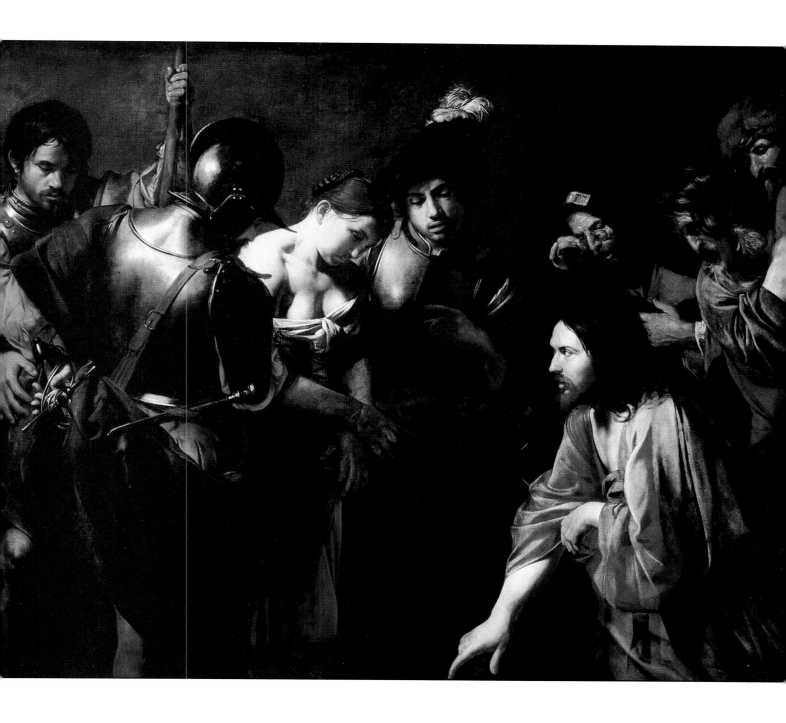

Valentin de Boulogne 1591-1632
Valentin was a French painter in the tenebrist style. He likely received his first training with his father in his native Coulommiers, near Paris. He may subsequently have studied with an artist in Paris or in Fontainebleau. The closer ties Valentin began to forge with other French artists after 1620 yielded an invitation by Vouet, Principe of the Accademia di San Luca, to organize with Nicolas Poussin (1594-1665) the festival of the academy's patron saint in 1626. Valentin seems to have moved increasingly from genre paintings to Biblical subjects during the third decade of the century.

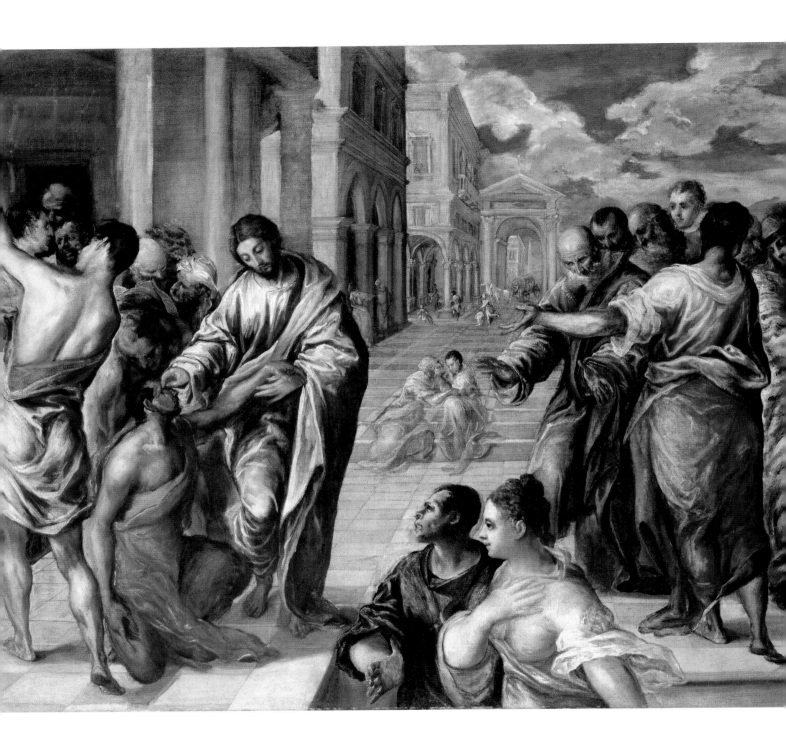

Healing the Man Born Blind *John 9:1-11*

As He passed by, He saw a man blind from birth. His disciples asked Him, "Rabbi, who sinned, this man or his parents, that he was born blind?" Jesus answered, "This man didn't sin, nor did his parents, but that the works of God might be revealed in him. I must work the works of Him who sent me while it is day. The night is coming, when no one can work. While I am in the world, I am the light of the world." When He had said this, He spat on the ground, made mud with the saliva, anointed the blind man's eyes with the mud, and said to him, "Go, wash in the pool of Siloam" (which means "Sent"). So he went away, washed, and came back seeing.

Doménikos Theotokópoulos 1541-1614
Most widely known as El Greco (The Greek), Theotokópoulos was a Greek painter, sculptor, and architect of the Spanish Renaissance. "El Greco" was a nickname, a reference to his Greek origin. El Greco was born in the Kingdom of Candia (modern Crete), which, at that time, was part of the Republic of Venice and the center of Post-Byzantine art. He trained and became a master within that tradition before traveling to Venice at the age of 26. He moved to Rome in 1570, where he opened a workshop and executed a series of works. During his stay in Italy, El Greco enriched his style with elements of Mannerism and of the Venetian Renaissance, taken from several great artists of the time, notably Tintoretto. In 1577, he moved to Toledo, Spain, where he lived and worked until his death. In Toledo, El Greco produced his best-known paintings.

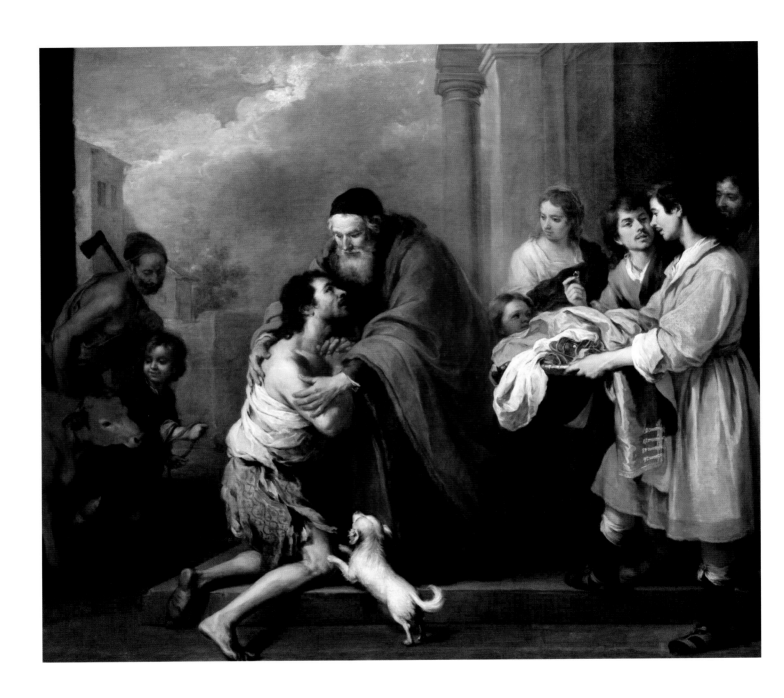

Bartolomé Murillo 1617-1682

After another period in Madrid (1658-1660), Murillo returned to Seville. He was one of the Academia de Bellas Artes (Academy of Art) founders and shared its direction in 1660 with architect Francisco Herrera the Younger. Murillo experienced a period of most significant activity during this time. He received numerous important commissions, among them the altarpieces for the Augustinian monastery, the paintings for Santa María la Blanca (completed in 1665), and others. Murillo had many pupils and followers. The prolific imitation of his paintings ensured his reputation in Spain and fame throughout Europe. Before the 19th century, Murillo's work was more well-known than any other Spanish artist. He died in 1682, a few months after he fell from a scaffold working on a fresco at the church of the Capuchins in Cádiz.

The Parable of the Prodigal Son *Luke 15:11-32*

Jesus said, "A certain man had two sons. The younger of them said to his father, 'Father, give me my share of your property.' So he divided his livelihood between them. Not many days after, the younger son gathered all of this together and traveled into a far country. There he wasted his property with riotous living. When he had spent all of it, there arose a severe famine in that country, and he began to be in need. He went and joined himself to one of the citizens of that country, and he sent him into his fields to feed pigs. He wanted to fill his belly with the pods that the pigs ate, but no one gave him any. But when he came to himself, he said, 'How many hired servants of my father's have bread enough to spare, and I'm dying with hunger! I will get up and go to my father, and will tell him, "Father, I have sinned against heaven and in your sight. I am no more worthy to be called your son. Make me as one of your hired servants."'" "He arose and came to his father. But while he was still far off, his father saw him and was moved with compassion, and ran, fell on his neck, and kissed him. The son said to him, 'Father, I have sinned against heaven and in your sight. I am no longer worthy to be called your son.' "But the father said to his servants, 'Bring out the best robe and put it on him. Put a ring on his hand and sandals on his feet. Bring the fattened calf, kill it, and let's eat and celebrate; for this, my son, was dead and is alive again. He was lost and is found.' Then they began to celebrate.

"Now his elder son was in the field. As he came near to the house, he heard music and dancing. He called one of the servants to him and asked what was going on. He said to him, 'Your brother has come, and your father has killed the fattened calf, because he has received him back safe and healthy.' But he was angry and would not go in. Therefore his father came out and begged him. But he answered his father, 'Behold, these many years I have served you, and I never disobeyed a commandment of yours, but you never gave me a goat, that I might celebrate with my friends. But when this your son came, who has devoured your living with prostitutes, you killed the fattened calf for him.' "He said to him, 'Son, you are always with me, and all that is mine is yours. But it was appropriate to celebrate and be glad, for this, your brother, was dead, and is alive again. He was lost, and is found.'"

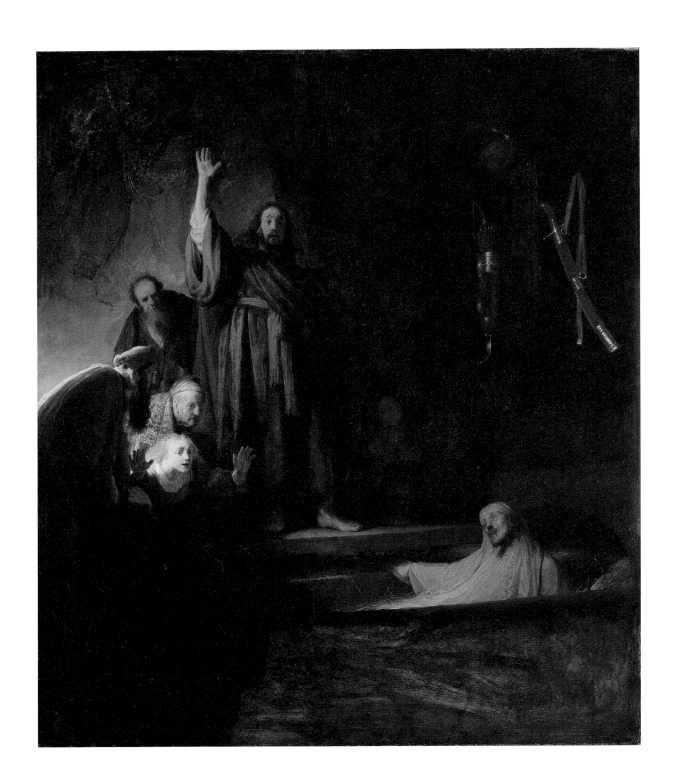

Rembrandt 1660-1669

Rembrandt is generally considered one of the greatest painters in European art and the most important in Dutch history. His contributions to art in a period of great wealth and cultural achievement that historians call the Dutch Golden Age are, in many ways, antithetical to the Baroque style that dominated Europe at that time. Rembrandt was extremely prolific and innovative, giving rise to important new genres in painting. His works are prominently characterized by his use of chiaroscuro (the theatrical use of light and dark shadows). Kenneth Clark said, "Because of his empathy for the human condition, he is one of the greatest visual prophets of civilization."

Jesus Raises Lazarus from the Dead *John 11:17-49*

So when Jesus came, He found that he had been in the tomb four days already. Now Bethany was near Jerusalem, about two miles away. Many of the Jews had joined the women around Martha and Mary, to console them concerning their brother. Then when Martha heard that Jesus was coming, she went and met Him, but Mary stayed in the house. Therefore Martha said to Jesus, "Lord, if You would have been here, my brother wouldn't have died. Even now I know that whatever You ask of God, God will give You." Jesus said to her, "Your brother will rise again." Martha said to Him, "I know that he will rise again in the resurrection at the last day." Jesus said to her, "I am the resurrection and the life. He who believes in Me will still live, even if he dies. Whoever lives and believes in Me will never die. Do you believe this?" She said to Him, "Yes, Lord. I have come to believe that You are the Christ, God's Son, He who comes into the world."

When she had said this, she went away and called Mary, her sister, secretly, saying, "The Teacher is here and is calling you." When she heard this, she arose quickly and went to Him.

Now Jesus had not yet come into the village, but was in the place where Martha met Him. Then the Jews who were with her in the house and were consoling her, when they saw Mary, that she rose up quickly and went out, followed her, saying, "She is going to the tomb to weep there." Therefore when Mary came to where Jesus was and saw Him, she fell down at His feet, saying to Him, "Lord, if you would have been here, my brother wouldn't have died." When Jesus therefore saw her weeping, and the Jews weeping who came with her, He groaned in the spirit and was troubled, and said, "Where have you laid him?" They told him, "Lord, come and see." Jesus wept.

Continued in Appendix

The Rich Young Ruler *Matthew 19:16-22*

Behold, one came to Him and said, "Good teacher, what good thing shall I do, that I may have eternal life?" He said to him, "Why do you call me good? No one is good but one, that is, God. But if you want to enter into life, keep the commandments." He said to Him, "Which ones?" Jesus said, "'You shall not murder.' 'You shall not commit adultery.' 'You shall not steal.' 'You shall not offer false testimony.' 'Honor your father and your mother.' And, 'You shall love your neighbor as yourself.'" The young man said to Him, "All these things I have observed from my youth. What do I still lack?" Jesus said to him, "If you want to be perfect, go, sell what you have, and give to the poor, and you will have treasure in heaven; and come, follow me." But when the young man heard this, he went away sad, for he was one who had great possessions.

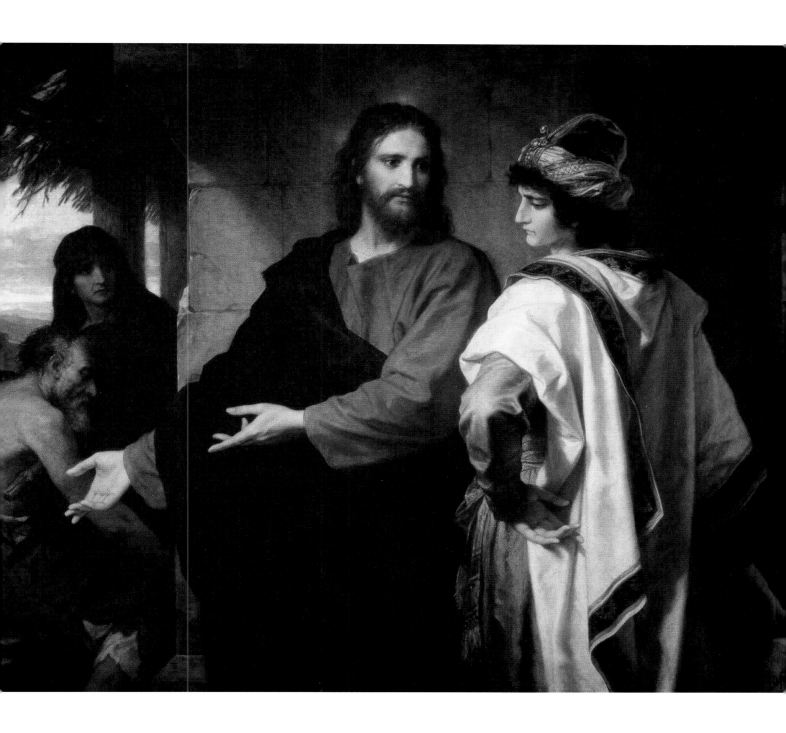

Heinrich Hofmann 1824-1911
The Sunday Strand, a popular British magazine at the time, described Hofmann as the most influential contemporary German painter. Hofmann's style of painting was unique, but at the same time, he based his work on the traditional art of old German, Dutch and Italian masters. Throughout his life, he remained faithful to the great examples of the Renaissance. Religious paintings take center stage in Hofmann's work.

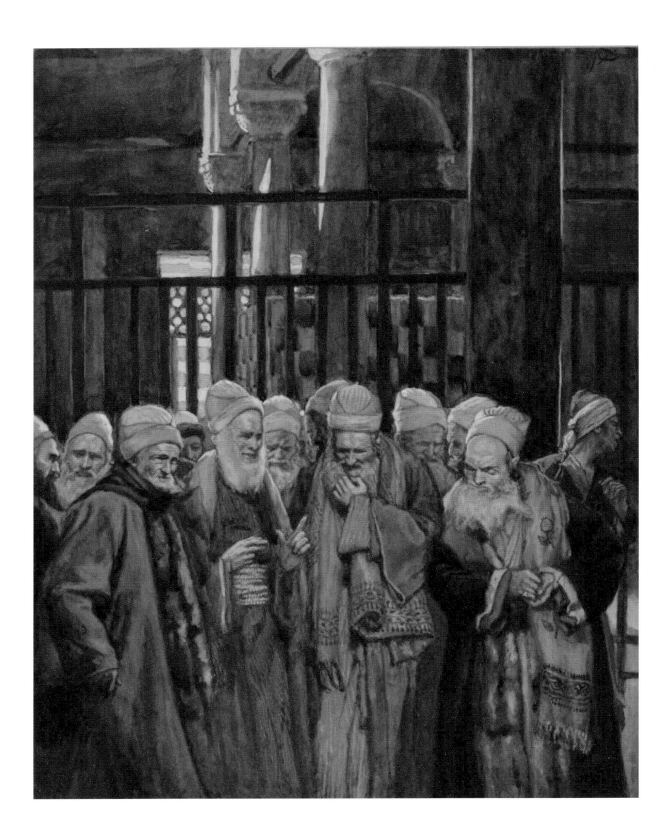

Conspiracy to Kill Jesus *John 11:47-53*

The chief priests therefore and the Pharisees gathered a council, and said, "What are we doing? For this man does many signs. If we leave Him alone like this, everyone will believe in Him, and the Romans will come and take away both our place and our nation." But a certain one of them, Caiaphas, being high priest that year, said to them, "You know nothing at all, nor do you consider that it is advantageous for us that one man should die for the people, and that the whole nation not perish." Now he didn't say this of himself, but being high priest that year, he prophesied that Jesus would die for the nation, and not for the nation only, but that He might also gather together into one the children of God who are scattered abroad. So from that day forward they took counsel that they might put Him to death.

Jesus therefore walked no more openly among the Jews, but departed from there into the country near the wilderness, to a city called Ephraim. He stayed there with His disciples.

Now the Passover of the Jews was at hand. Many went up from the country to Jerusalem before the Passover, to purify themselves. Then they sought for Jesus and spoke with one another as they stood in the temple, "What do you think—that He isn't coming to the feast at all?" Now the chief priests and the Pharisees had commanded that if anyone knew where He was, he should report it, that they might seize Him.

Jacques Tissot 1836-1902
Tissot was born in Nantes, France, and knew he wanted to pursue painting as a career at the age of 17. By 1854 he was commonly known as James Tissot, a name he adopted because of his increasing interest in everything English. In 1885, a revival of his Catholic faith led him to spend the rest of his life making paintings about Biblical events. Many of his artist friends were skeptical about his conversion, as it conveniently coincided with the French Catholic revival, a reaction against the secular attitude of the French Third Republic. When French artists were working in impressionism, pointillism, and heavy oil washes, Tissot was moving toward realism in his watercolors. To assist in his completion of biblical illustrations, Tissot traveled to the Middle East in 1886, 1889, and 1896 to study the landscape and people.

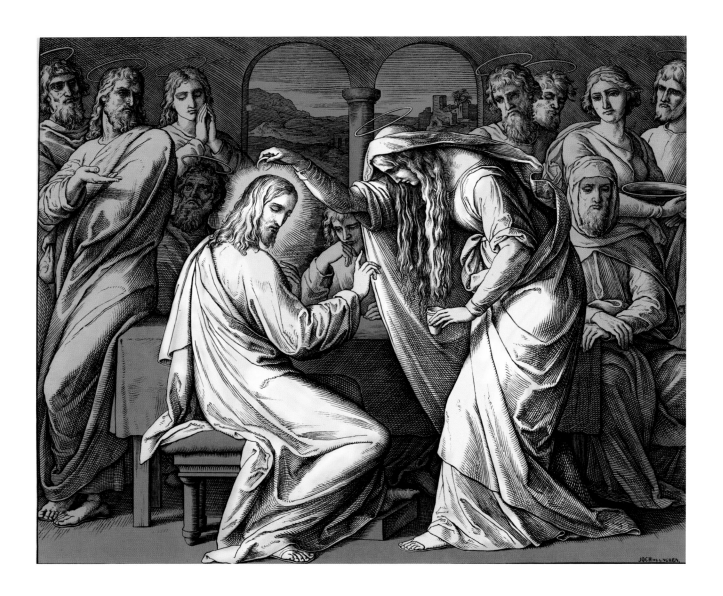

Julius Schnorr von Carolsfeld 1794-1872
Carolsfeld was a German painter, chiefly of Biblical subjects. As a young man, he associated with the painters of the Nazarene movement who revived the elaborate Renaissance style in religious art. He is remembered for his extensive *Picture Bible*, and his designs for stained glass windows in cathedrals. His *Picture Bible* was published in Leipzig in 30 parts from 1852-60, and an English edition followed in 1861. His style differs from the simplicity and severity of earlier times, exhibiting the floridity of the later Renaissance.

The Precious Ointment *Matthew 26:6-13*

Now when Jesus was in Bethany, in the house of Simon the leper, a woman came to Him having an alabaster jar of very expensive ointment, and she poured it on His head as He sat at the table. But when His disciples saw this, they were indignant, saying, "Why this waste? For this ointment might have been sold for much and given to the poor." However, knowing this, Jesus said to them, "Why do you trouble the woman? She has done a good work for me. For you always have the poor with you, but you don't always have me. For in pouring this ointment on my body, she did it to prepare me for burial. Most certainly I tell you, wherever this Good News is preached in the whole world, what this woman has done will also be spoken of as a memorial of her."

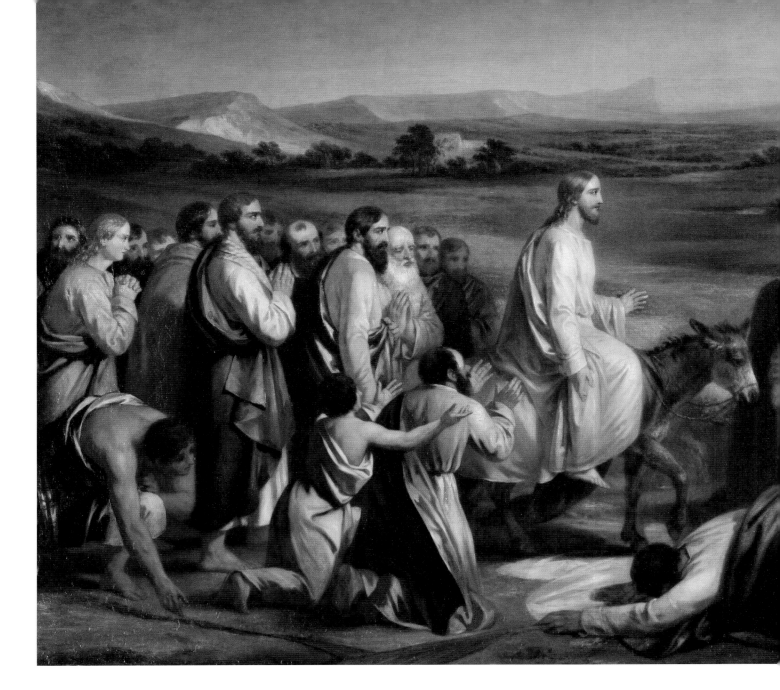

The Triumphal Entry *Matthew 21:1-11*

W hen they came near to Jerusalem and came to Bethphage, to the Mount of Olives, then Jesus sent two disciples, saying to them, "Go into the village that is opposite you, and immediately you will find a donkey tied, and a colt with her. Untie them and bring them to me. If anyone says anything to you, you shall say, 'The Lord needs them,' and immediately he will send them."

All this was done that it might be fulfilled which was spoken through the prophet, saying, "Tell the daughter of Zion, behold, your King comes to you, humble, and riding on a donkey, on a colt, the foal of a donkey." The disciples went and did just as Jesus commanded them, and brought the donkey and the colt and laid their clothes on them; and He sat on them. A very great multitude spread their clothes on the road. Others cut branches from the trees and spread them on the road. The multitudes who

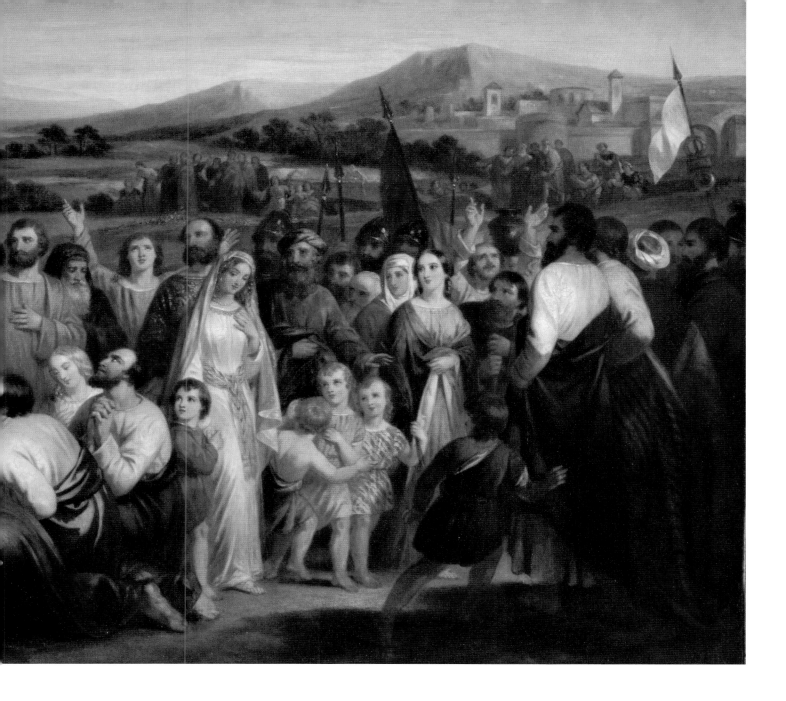

went in front of Him, and those who followed, kept shouting, "Hosanna to the son of David! Blessed is He who comes in the name of the Lord! Hosanna in the highest!" When He had come into Jerusalem, all the city was stirred up, saying, "Who is this?" The multitudes said, "This is the prophet, Jesus, from Nazareth of Galilee."

James Wood 1889-1975
A painter, draughtsman, and writer born in Southport, Lancashire, Wood studied painting in Paris with Percyval Tudor-Hart. During World War I, he was in the army and Royal Flying Corps, later working on battleship camouflage. Post-war, Woods wrote *The Foundations of Aesthetics* with C. K. Ogden and I. A. Richards. He also wrote on color harmony, a favorite topic, and in 1926 published *New World Vistas*, an autobiographical work. From the 1930s, he became increasingly fascinated by Persian Art. Wood learned Persian and subsequently became an art advisor to the Persian government. Kandinsky influenced his paintings, and he showed them at Leicester and Zwemmer Galleries in solo exhibitions.

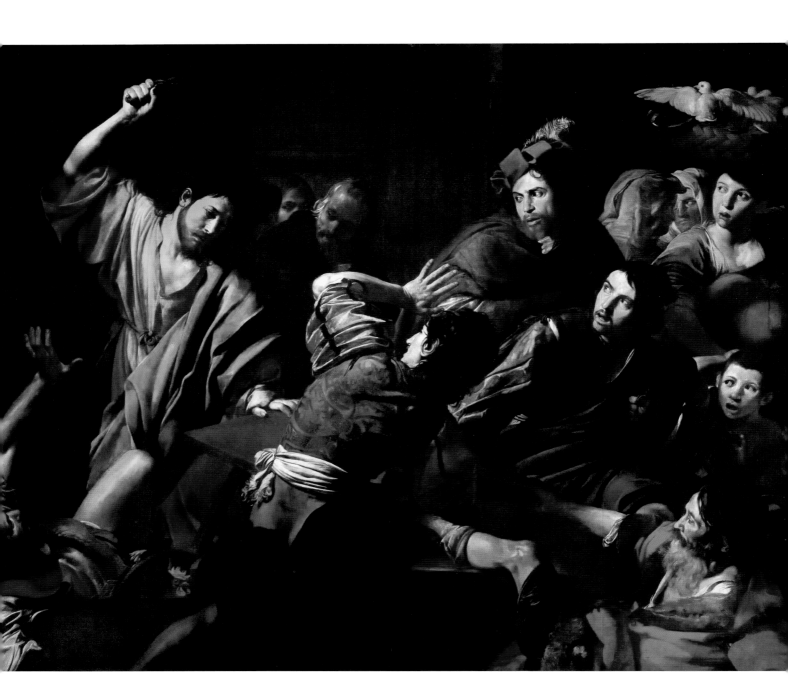

Jesus Drives Money Changers from the Temple

Mark 11:15-18

They came to Jerusalem, and Jesus entered into the temple and began to throw out those who sold and those who bought in the temple, and overthrew the money changers' tables and the seats of those who sold the doves. He would not allow anyone to carry a container through the temple. He taught, saying to them, "Isn't it written, 'My house will be called a house of prayer for all the nations?' But you have made it a den of robbers! The chief priests and the scribes heard it, and sought how they might destroy Him. For they feared Him, because all the multitude was astonished at His teaching.

Valentin de Boulogne 1591-1632
Valentin painted many figures of saints or prophets as well as the more occasional narrative scenes including *Christ Expelling the Merchants from the Temple* (St. Petersburg, State Hermitage Museum). Recounting the artist's early death in 1632, Giovanni Baglione wrote that, "Valentin passed the night away in a tavern during the heat of the summer. The great quantity of tobacco and excess of wine he consumed produced within him an overwhelming internal heat. On passing the Fontana del Babuino, Valentin leaped in, hoping to cool himself down. The cold water only consolidated the heat and he contracted a terrible fever, from which he died in a few days."

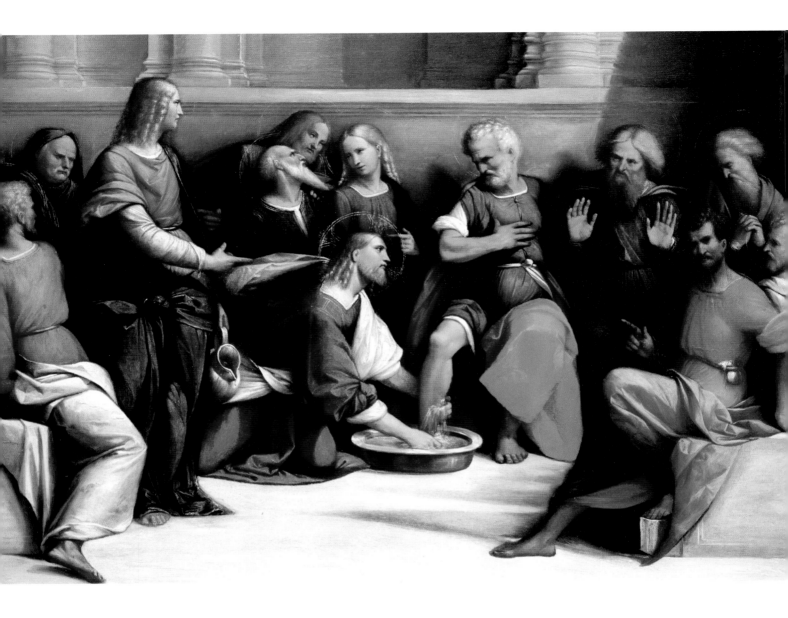

Benvenuto Tisi 1481-1559
Tisi, also called Garofalo, was a late-Renaissance-Mannerist Italian painter of the School of Ferrara, whose career began attached to the court of the Duke d'Este. His early works have been described as "idyllic," but they often conform to the elaborate conceits favored by the artistically refined Ferrarese court. Born in Canaro near Ferrara, Tisi is claimed to have apprenticed under Panetti and perhaps Costa and was a contemporary and sometimes collaborator with Dosso Dossi. In 1495, he worked at Cremona under his maternal uncle Niccolò Soriano, who initiated him into Venetian coloring at the school of Boccaccino. He also spent time in Rome, where he worked briefly under Raphael. Two of his principal works are *Massacre of the Innocents* (1519) in the church of St. Francesco, and his masterpiece, *Betrayal of Christ* (1524). He continued at his work until 1550, when blindness overtook him.

Jesus Washes the Disciples' Feet *John 13:13-17*

Jesus, knowing that the Father had given all things into His hands, and that He came from God and was going to God, arose from supper, and laid aside His outer garments. He took a towel and wrapped a towel around His waist. Then He poured water into the basin, and began to wash the disciples' feet and to wipe them with the towel that was wrapped around Him. Then He came to Simon Peter. He said to Him, "Lord, do you wash my feet?" Jesus answered him, "You don't know what I am doing now, but you will understand later." Peter said to Him, "You will never wash my feet!" Jesus answered him, "If I don't wash you, you have no part with me." Simon Peter said to Him, "Lord, not my feet only, but also my hands and my head!" Jesus said to him, "Someone who has bathed only needs to have his feet washed, but is completely clean. You are clean, but not all of you." For He knew him who would betray Him; therefore he said, "You are not all clean."

So when He had washed their feet, put His outer garment back on, and sat down again, He said to them, "Do you know what I have done to you? You call me, 'Teacher' and 'Lord.' You say so correctly, for so I am. If I then, the Lord and the Teacher, have washed your feet, you also ought to wash one another's feet. For I have given you an example, that you should also do as I have done to you. Most certainly I tell you, a servant is not greater than his lord, neither is one who is sent greater than he who sent him. If you know these things, blessed are you if you do them."

The Last Supper *Mark 14:17-26*

When it was evening He came with the twelve. As they sat and were eating, Jesus said, "Most certainly I tell you, one of you will betray me—he who eats with me." They began to be sorrowful, and to ask Him one by one, "Surely not I?" And another said, "Surely not I?" He answered them, "It is one of the twelve, he who dips with me in the dish. For the Son of Man goes as it is written about him, but woe to that man by whom the Son of Man is betrayed! It would be better for that man if he had not been born."

As they were eating, Jesus took bread, and when He had blessed it, He broke it and gave to them, and said, "Take, eat. This is my body." He took the cup, and when He had given thanks, He gave to them. They all drank of it. He said to them, "This is my blood of the new covenant, which is poured out for many. Most certainly I tell you, I will no more drink of the fruit of the vine until that day when I drink it anew in God's Kingdom." When they had sung a hymn, they went out to the Mount of Olives.

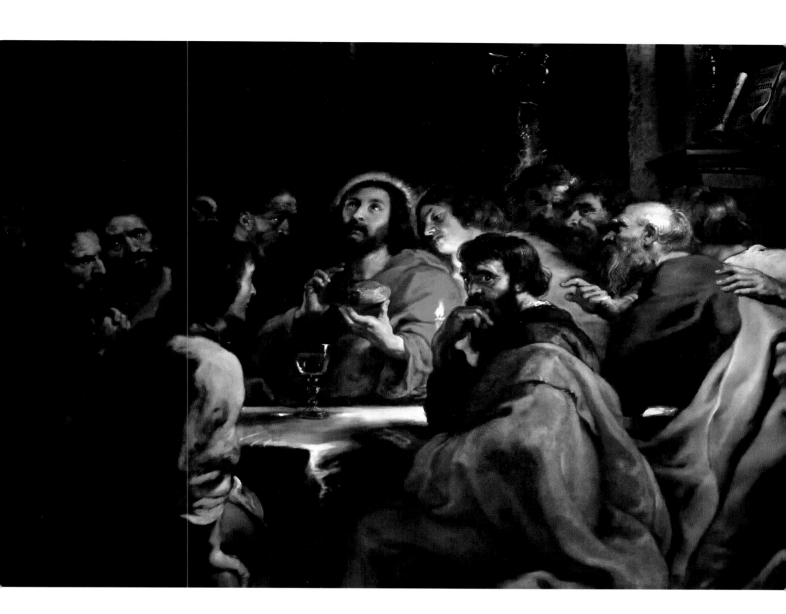

Peter Paul Rubens 1577-1640
Rubens was a Flemish artist and diplomat from the Duchy of Brabant in the Southern Netherlands (modern-day Belgium) who lived during the Dutch Golden Age. He is considered the most influential artist of the Flemish Baroque tradition. Rubens' highly charged compositions reference erudite aspects of classical and Christian history. His unique and immensely popular Baroque style emphasized movement, color, and sensuality, which followed the immediate, dramatic artistic style promoted in the Counter-Reformation.

If you recall, I wrote in the introduction about all the prophesies that were fulfilled by Jesus. As you read on and study the following paintings, you will be zooming in on the final days of Jesus here on Planet Earth, and then, we will zoom in even closer as we witness the day, the final day. This day was written about by Isaiah, the Old Testament prophet, in 700 BC, give or take a few years. Many of the details that Isaiah writes about took place on the day that Jesus was crucified. They were written in advance for you, and for me, so that we would not only know the truth but that we would believe that Jesus IS the Savior of the world.

Please read very carefully and thoughtfully Isaiah 53. Keep this passage of scripture in mind as you continue to read the story and study the following paintings.

Isaiah 53
The Suffering Servant

Who has believed our message?

To whom has Yahweh's arm been revealed?

For He grew up before Him as a tender plant,

and as a root out of dry ground. He has no good looks or majesty.

When we see Him, there is no beauty that we should desire Him.

He was despised and rejected by men,

a man of suffering and acquainted with grief.

He was despised as one from whom men hide their face;

and we didn't respect Him.

Surely He has borne our sickness and carried our suffering;

yet we considered Him plagued, struck by God, and afflicted.

But He was pierced for our transgressions.

He was crushed for our iniquities.

The punishment that brought our peace was on Him;

and by His wounds we are healed.

All we like sheep have gone astray.

Everyone has turned to his own way;

and the LORD has laid on Him the iniquity of us all.

He was oppressed,

yet when He was afflicted He didn't open His mouth.

As a lamb that is led to the slaughter,

and as a sheep that before its shearers is silent,

so He didn't open His mouth.

He was taken away by oppression and judgment.

As for His generation,

who considered that He was cut off out of the land of the living

and stricken for the disobedience of my people?

They made His grave with the wicked,

and with a rich man in His death,

although He had done no violence,

nor was any deceit in His mouth.

Yet it pleased God to bruise Him.

He has caused Him to suffer.

When you make His soul an offering for sin,

He will see His offspring. He will prolong His days

and God's pleasure will prosper in His hand.

After the suffering of His soul,

He will see the light and be satisfied.

My righteous servant will justify many by the knowledge of Himself;

and He will bear their iniquities.

Therefore I will give Him a portion with the great.

He will divide the plunder with the strong,

because He poured out His soul to death

and was counted with the transgressors;

yet He bore the sins of many

and made intercession for the transgressors.

Jesus in Gethsemane *Mark 14:32-42*

They came to a place which was named Gethsemane. He said to His disciples, "Sit here while I pray." He took with him Peter, James, and John, and began to be greatly troubled and distressed. He said to them, "My soul is exceedingly sorrowful, even to death. Stay here and watch." He went forward a little, and fell on the ground, and prayed that if it were possible, the hour might pass away from Him. He said, "Abba, Father, all things are possible to you. Please remove this cup from me. However, not what I desire, but what you desire." He came and found them sleeping, and said to Peter, "Simon, are you sleeping? Couldn't you watch one hour? Watch and pray, that you may not enter into temptation. The spirit indeed is willing, but the flesh is weak." Again He went away and prayed, saying the same words. Again He returned and found them sleeping, for their eyes were very heavy; and they didn't know what to answer Him. He came the third time and said to them, "Sleep on now, and take your rest. It is enough. The hour has come. Behold, the Son of Man is betrayed into the hands of sinners. Arise! Let's get going. Behold, he who betrays me is at hand."

Nikolai Nikolaevich Sapunov 1880-1912
Born in Moscow, Nikolai was a Russian painter who studied under Isaac Levitan (1893–1901) and at the Imperial Academy of Arts in St. Petersburg. He painted sets for the Bolshoi Theatre in Moscow based on designs by Korovin (1901-1902), sets and costumes for Moscow Art Theatre (from 1904), sets and costumes for Meyerhold's 1906 production of Alexander Blok's *The Puppet Show*, theatres of Vera Komissarzhevskay, and experimental theatre of Alexandr Tairov. At the end of his life, he began a series of ironic genre pictures, which he left unfinished as he wished to go abroad. Nikolai Sapunov drowned in a boating accident in Terioki, Finland, at the age of 32.

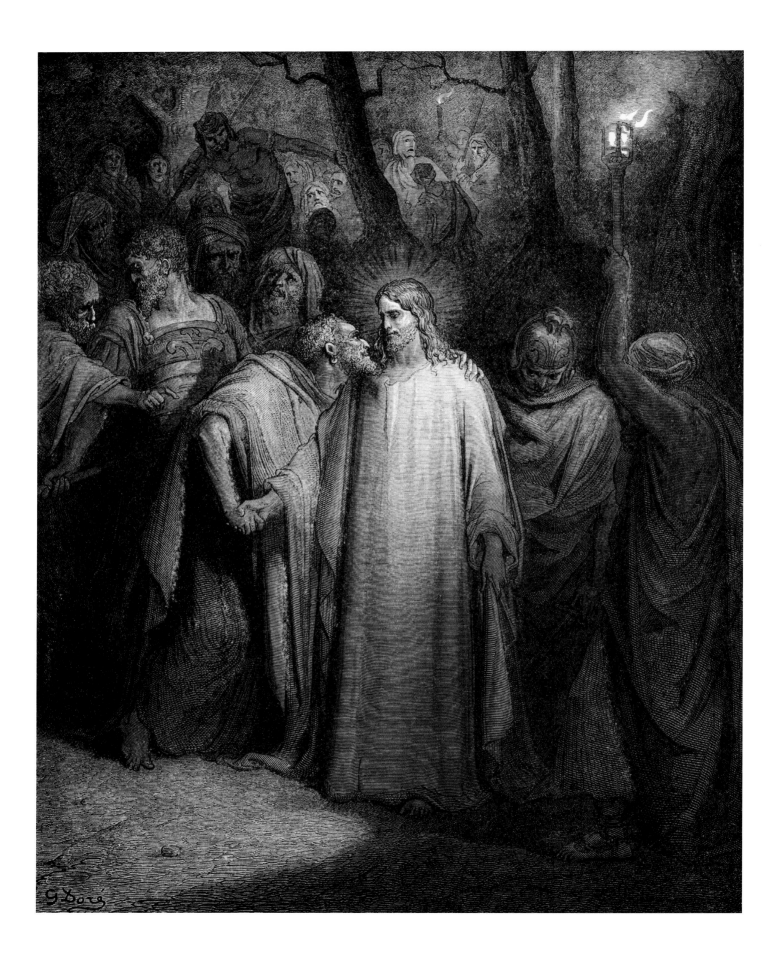

The Judas Kiss *Luke 22:47-48*

While He was still speaking, a crowd appeared. He

who was called Judas, one of the twelve, was leading

them. He came near to Jesus to kiss Him. Jesus said to

him, "Judas, do you betray the Son of Man with a kiss?"

Gustave Doré 1832-1883
Doré suffered rejection at the hands of the critics of his day, just like his exact contemporary
Edouard Manet. Whereas Manet became the modern age hero, Doré has remained for many the
most renowned illustrator. Some of his illustrations for the Bible or *Dante's Inferno* are permanently
etched in the collective consciousness. Doré's reputation as a "preacher painter" was established in
the last third of his career, after his famous illustrations for the *Holy Bible* in 1866. A short while later,
he undertook several spectacular religious works for the Doré Gallery in London, co-founded in
1867-1868.

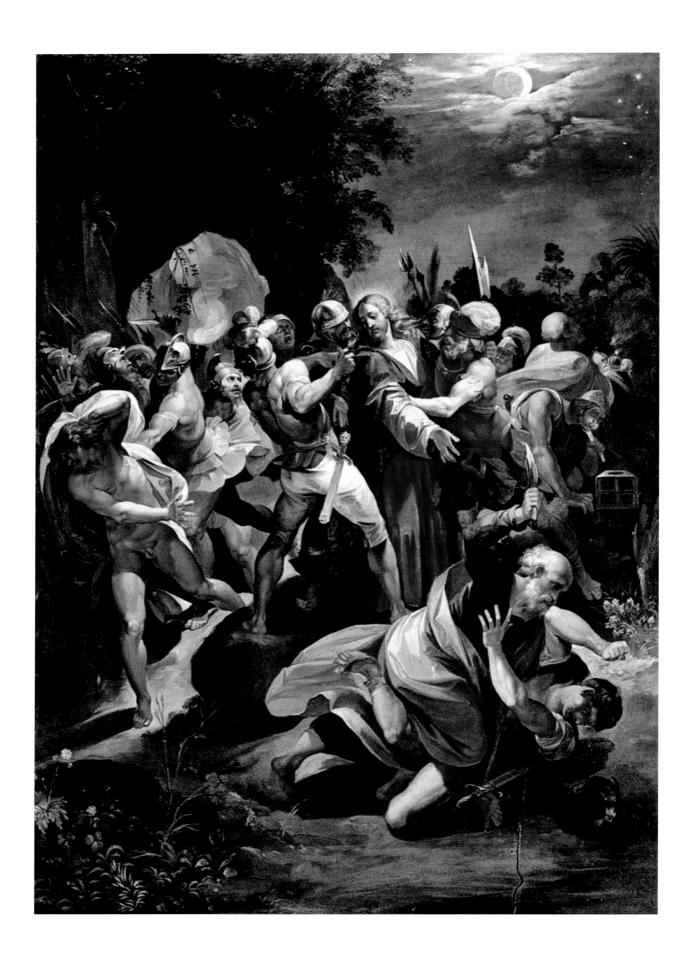

Christ Taken Prisoner *Mark 14:46-53*

They laid their hands on Him and seized Him. But a certain one of those who stood by drew his sword and struck the servant of the high priest, and cut off his ear. Jesus answered them, "Have you come out, as against a robber, with swords and clubs to seize me? I was daily with you in the temple teaching, and you didn't arrest me. But this is so that the Scriptures might be fulfilled." They all left Him, and fled.

A certain young man followed Him, having a linen cloth thrown around himself over his naked body. The young men grabbed him, but he left the linen cloth and fled from them naked. They led Jesus away to the high priest. All the chief priests, the elders, and the scribes came together with Him.

Giuseppe Cesari 1568-1640
Cesari was an Italian Mannerist painter patronized in Rome by Clement and Sixtus V; he was chief of the studio in which Caravaggio trained. His brother Bernardino assisted in many of his works. Cesari became a member of the Accademia di San Luca in 1585. His position as the most prominent painter in Rome brought him the commission for scenes of Roman history in the Palazzo dei Conservatori in 1595 and close personal ties with the papal court. Although he never adapted to the radical changes brought about in Roman painting by his former student Caravaggio and by the Carracci and their followers, Cesari continued to receive significant commissions until his death in 1640. His only direct followers were his sons Muzio and Bernardino.

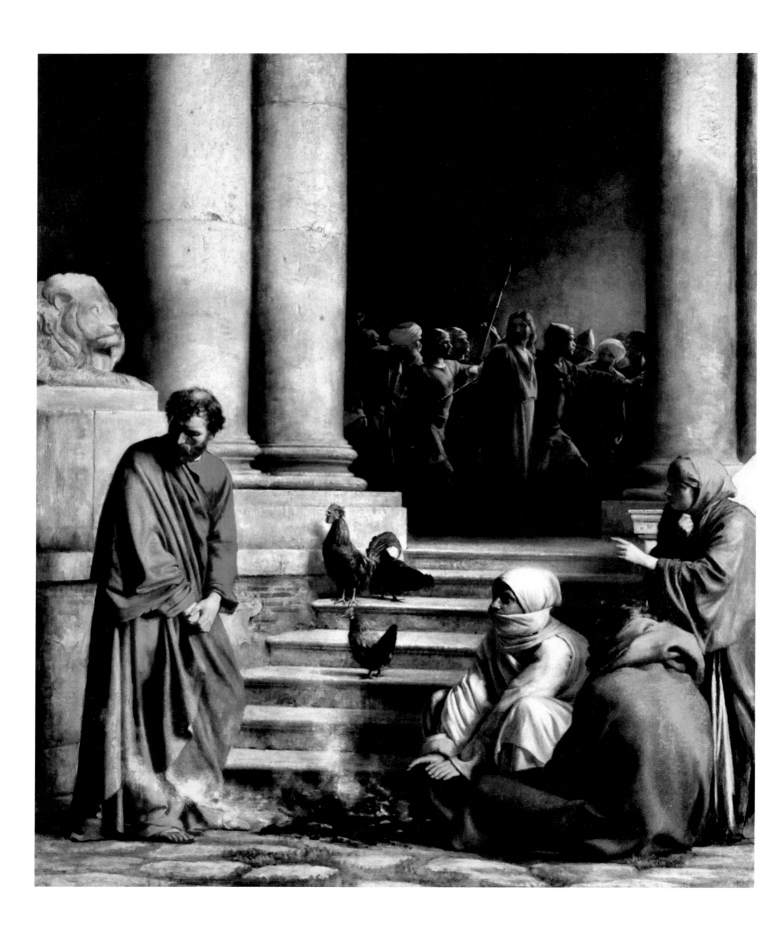

Peter's Denial *Mark 14:66-72*

Now Peter was sitting outside in the courtyard, and a servant-girl came to him and said, "You too were with Jesus the Galilean." But he denied it before them all, saying, "I do not know what you are talking about." When he had gone out to the gateway, another servant-girl saw him and said to those who were there, "This man was with Jesus of Nazareth." And again he denied it with an oath, "I do not know the man." A little later the bystanders came up and said to Peter, "Surely you too are one of them; for even the way you talk gives you away." Then he began to curse and swear, "I do not know the man!" And immediately a rooster crowed. And Peter remembered the word which Jesus had said, "Before a rooster crows, you will deny Me three times." And he went out and wept bitterly.

Carl Heinrich Bloch 1834-1890
Bloch died of cancer on February 22, 1890. He was 56 years old. According to an article by Sophus Michaelis, his death came as "an abrupt blow for Nordic art." Michaelis stated that "Denmark has lost the artist that indisputably was the greatest among the living." A prominent Danish art critic, Karl Madsen, said that "Carl Bloch reached higher toward the great heaven of art than all other Danish art up to that date."

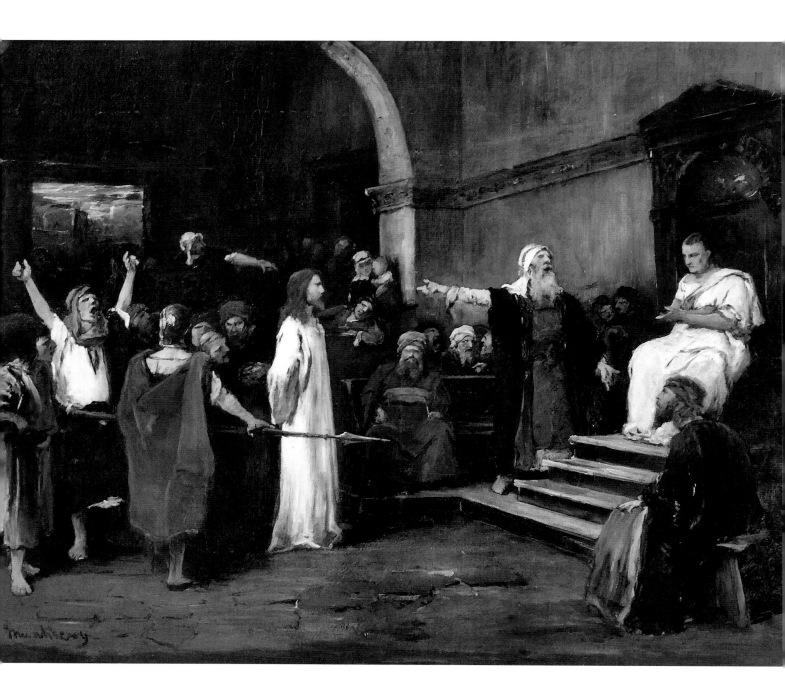

Jesus Before Pilate *John 18:33-38*

Pilate therefore entered again into the Praetorium, called Jesus, and said

to Him, Are You the King of the Jews?" Jesus answered him, "Do you say

this by yourself, or did others tell you about Me?" Pilate answered, "I'm

not a Jew, am I? Your own nation and the chief priests delivered You to

me. What have You done?" Jesus answered, "My Kingdom is not of this

world. If My Kingdom were of this world, then My servants would fight,

that I wouldn't be delivered to the Jews. But now My Kingdom is not

from here." Pilate therefore said to Him, "Are You a king then?" Jesus

answered, "You say that I am a king. For this reason I have been born, and

for this reason I have come into the world, that I should testify to the truth.

Everyone who is of the truth listens to My voice." Pilate said to Him,

"What is truth?"

Mihály Munkácsy 1844-1900
Munkácsy was a Hungarian painter who earned an international reputation with his genre pictures and large-scale biblical paintings. After being apprenticed to itinerant painter Elek Szamossy, Munkácsy went to Pest, the largest city in Hungary (now part of Budapest), where he sought the patronage of established artists. After traveling to Paris to see the Universal Exposition, his style became lighter, with broader brushstrokes and tonal color schemes. In 1869, Munkácsy painted his much-acclaimed work *The Last Day of a Condemned Man*, considered his first masterpiece. The painting was rewarded with the Gold Medal of the Paris Salon in 1870 and instantly made Munkácsy a famous painter. Munkácsy moved to Paris, where he lived until the end of his life. He married the widow of Baron de Marches in 1874, after which his style evolved; departing from the typical subjects of realism, he produced colorful still life and salon paintings.

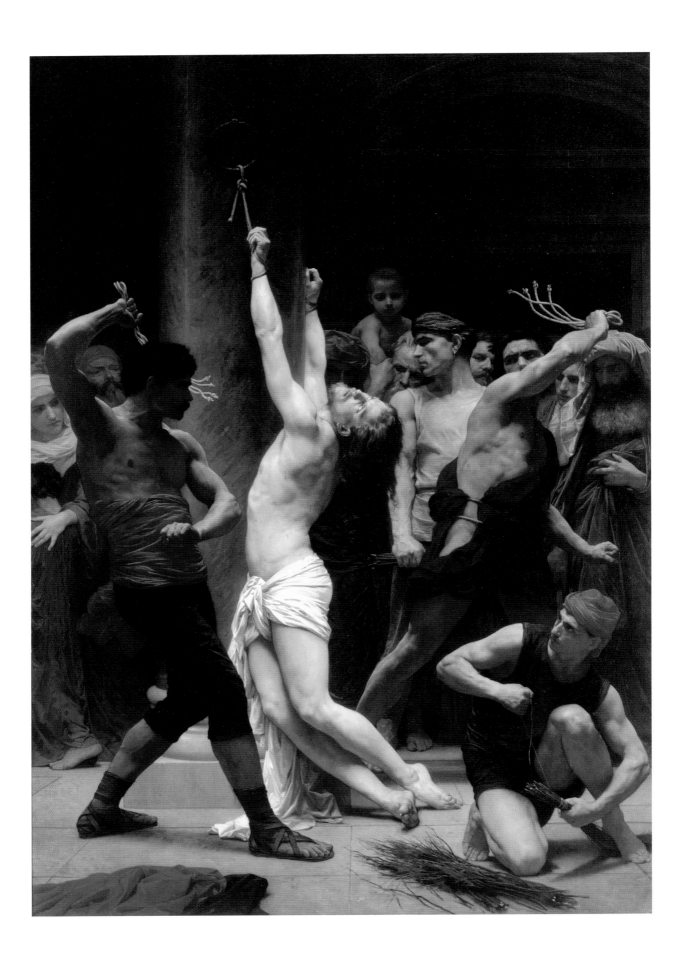

The Flagellation of Our Lord Jesus Christ
Matthew 27:24-26

So when Pilate saw that nothing was being gained, but rather that a disturbance was starting, he took water and washed his hands before the multitude, saying, "I am innocent of the blood of this righteous person. You see to it." All the people answered, "May His blood be on us and on our children!" Then he released Barabbas to them, but Jesus he flogged.

William-Adolphe Bouguereau 1825-1905
Bouguereau was a French academic painter. He used mythological themes in his realistic genre paintings, making modern interpretations of classical subjects emphasizing the human body. He enjoyed significant popularity in France and the United States during his life, was given numerous official honors and received top prices for his work. As the quintessential salon painter of his generation, he was reviled by the Impressionist avant-garde. Bouguereau completed 822 known paintings, although the whereabouts of many are still unknown.

Jesus Crowned with Thorns *Matthew 27:27-30*

Then the governor's soldiers took Jesus into the Praetorium, and

gathered the whole garrison together against Him. They stripped Him

and put a scarlet robe on Him. They braided a crown of thorns and

put it on His head, and a reed in His right hand; and they kneeled

down before Him and mocked Him, saying, "Hail, King of the Jews!"

They spat on Him, and took the reed and struck Him on the head.

Annibale Carracci 1560-1609

Carracci was an Italian painter and instructor, active in Bologna and later in Rome. Along with his brother and cousin, Annibale was one of the progenitors, if not founders of a leading strand of the Baroque style, which borrowed techniques from both north and south of their native city, and aspired for a return to classical monumentality while adding a more vital dynamism. Painters working under Annibale at the gallery of the Palazzo Farnese were highly influential in Roman painting for decades.

In 1609, Annibale died and was buried, according to his wish, near Raphael in the Pantheon of Rome. It is a measure of his achievement that artists as diverse as Bernini, Poussin, and Rubens praised his work. Many of his assistants or pupils in projects at the Palazzo Farnese and Herrera Chapel would become among the pre-eminent artists of the following decades, including Domenichino, Francesco Albani, Giovanni Lanfranco, Domenico Viola, Guido Reni, Sisto Badalocchio, and others.

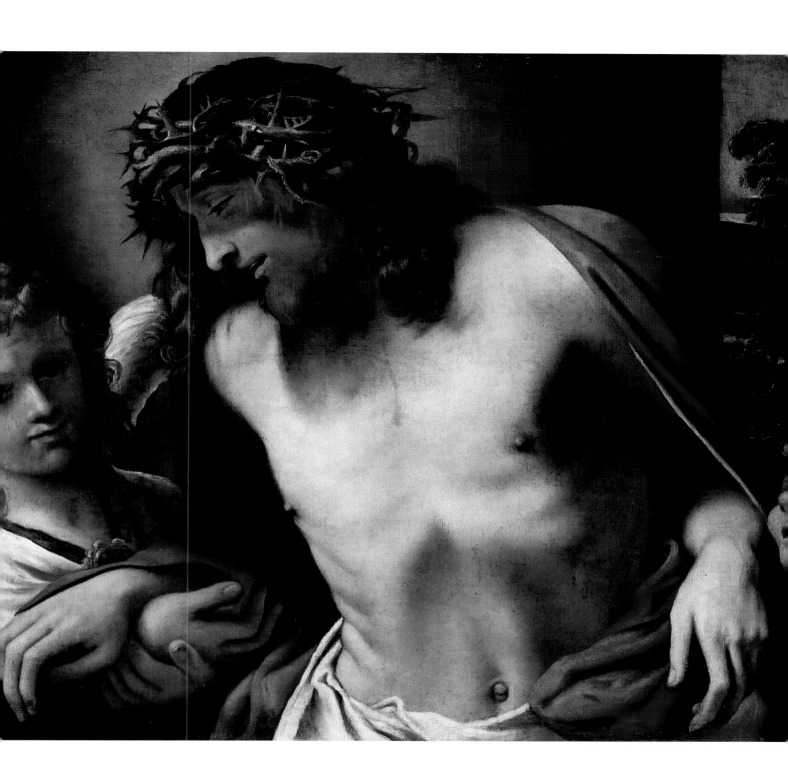

Ecce Homo (Behold the Man) *John 19:4-11*

Pilate went out again, and said to them, "Behold, I bring Him out to you, that you may know that I find no basis for a charge against Him." Jesus therefore came out, wearing the crown of thorns and the purple garment. Pilate said to them, "Behold, the man!" When therefore the chief priests and the officers saw Him, they shouted, saying, "Crucify! Crucify!" Pilate said to them, "Take Him yourselves and crucify Him, for I find no basis for a charge against Him." The Jews answered him, "We have a law, and by our law He ought to die, because He made himself the Son of God." When therefore Pilate heard this saying, he was more afraid. He entered into the Praetorium again, and said to Jesus, "Where are you from?" But Jesus gave him no answer. Pilate therefore said to Him, "Aren't You speaking to me? Don't You know that I have power to release You and have power to crucify You?" Jesus answered, "You would have no power at all against me, unless it were given to you from above. Therefore he who delivered Me to you has greater sin." He then handed Him over to them to be crucified.

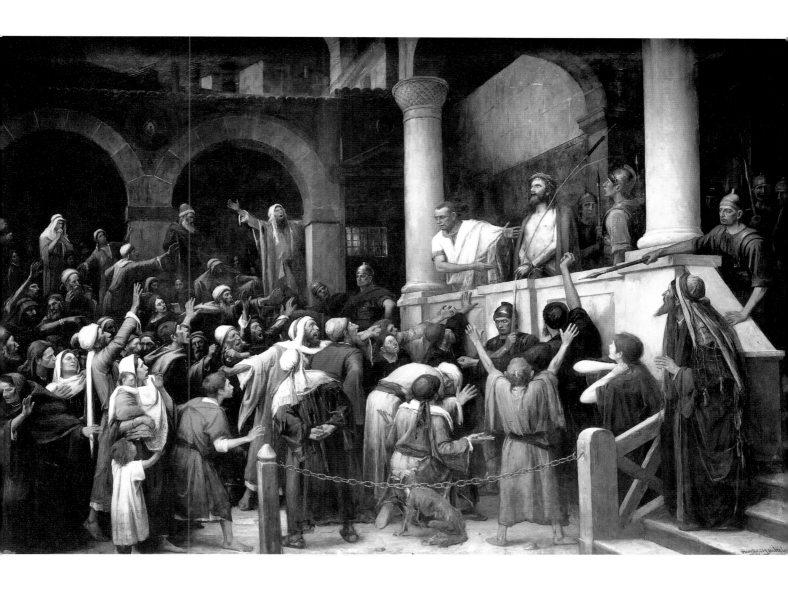

Mihály Munkácsy 1844-1900

In 1878, Munkácsy painted *The Blind Milton Dictating Paradise Lost to his Daughters*, a historical genre picture that marked a new milestone in his oeuvre (collection of work). The painting was bought (and successfully sold) by Austrian-born art dealer Charles Sedelmeyer, who offered Munkácsy a ten-year contract. This deal made Munkácsy wealthy and an established member of the Paris art world. Sedelmeyer wanted Munkácsy to paint large-scale pictures which could be exhibited on their own. They decided that a subject taken from the Bible would be most suitable. In 1882, Munkácsy painted *Christ in Front of Pilate*, followed by *Golgotha* in 1884. He completed the trilogy in 1896 with *Ecce Homo*, and Sedelmeyer took these three paintings on tour across Europe and the United States. Philadelphia department store magnate John Wanamaker purchased the first two. They were exhibited in the Grand Court of his Philadelphia store every Easter, with special Lenten music programs often arranged around them. The spaciousness of the Grand Court favorably accommodated the paintings' heroic size. They were kept in a special vault adjacent to the Wanamaker Organ during other parts of the year. Wanamaker reportedly paid the highest price for its time ever paid to a living artist.

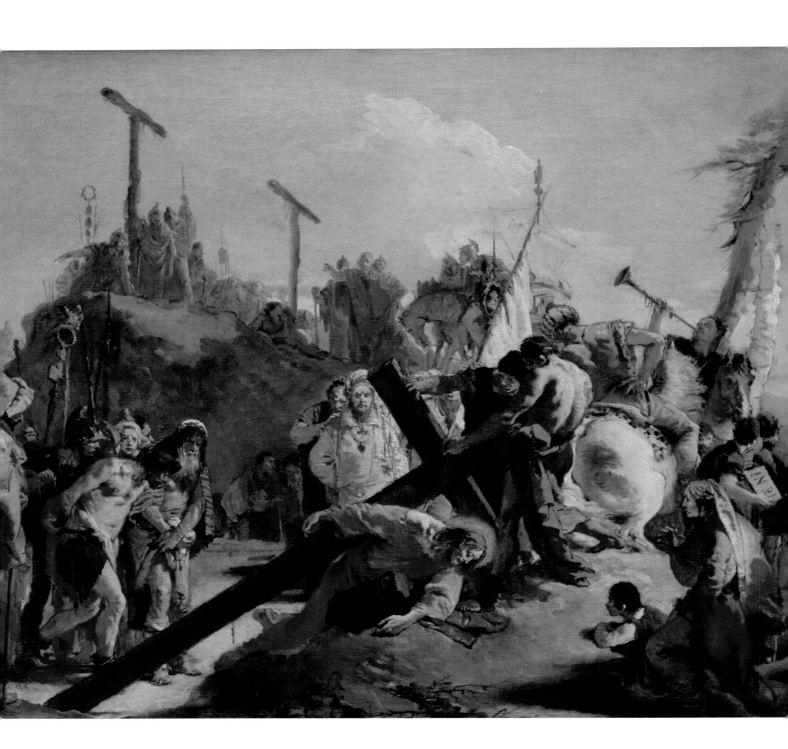

Christic Carrying His Cross *John 19:16-17, Luke 23:26-31*

So Pilate handed Him over to them to be crucified. Jesus went out bearing His own cross.

When they led Him away, they grabbed one Simon of Cyrene, coming from the country, and laid the cross on him to carry it after Jesus. A great multitude of the people followed Him, including women who also mourned and lamented Him. But Jesus, turning to them, said, "Daughters of Jerusalem, don't weep for me, but weep for yourselves and for your children. For behold, the days are coming in which they will say, 'Blessed are the barren, the wombs that never bore, and the breasts that never nursed.' Then they will begin to tell the mountains, 'Fall on us!' and tell the hills, 'Cover us.' For if they do these things in the green tree, what will be done in the dry?"

Giovanni Tiepolo 1696-1770
Tiepolo was an Italian painter from the Republic of Venice who painted in the Rococo style and was considered a significant member of the 18th-century Venetian school. He was prolific and worked not only in Italy but also in Germany and Spain. Tiepolo is considered one of the traditional Old Masters of that period. Successful from the beginning of his career, he has been described as the greatest decorative painter of eighteenth-century Europe.

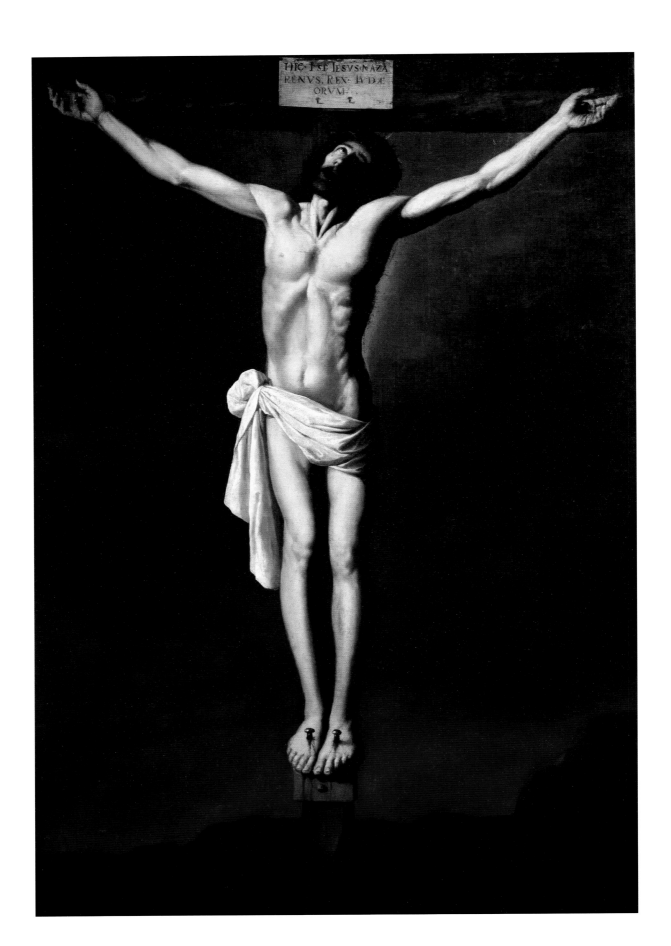

Christic Crucified

Matthew 27:33-35

When they came to a place called "Golgotha," that is to say, "The place of a skull," they gave Him sour wine to drink mixed with gall. When He had tasted it, He would not drink. Then they crucified Him...

Mark 15:22-24a

They brought Him to the place called Golgotha, which is, being interpreted, "The place of a skull." They offered Him wine mixed with myrrh to drink, but He didn't take it. And they crucified Him...

Luke 23:38

An inscription was also written over Him in letters of Greek, Latin, and Hebrew: "THIS IS THE KING OF THE JEWS."

John 19:17-18a

He went out, bearing His cross, to the place called "The Skull," which is called in Hebrew, "Golgotha," where they crucified Him...

Francisco de Zurbarán 1598-1644
Zurbarán was a Spanish painter in the baroque style. Born in Fuentes de Cantos, Badajoz Province, he was among the foremost artists of Spain's Golden Century. Zurbarán opened a workshop in Llerena in 1617. His art is an anomaly causing some art historians to dismiss him as second-rate and others to praise him unrestrainedly. While complex, one might surmise it stems from the paradox that Zurbarán was essentially a provincial profoundly involved with the infinite. This duality caused his art to be tense with opposites: sophisticated technique and ingenuous primitivism. His saints wear no halos; they mysteriously exhale the breath of divine grace. Fundamentally and almost exclusively, Zurbarán was a painter of religious subjects by his own free choice.

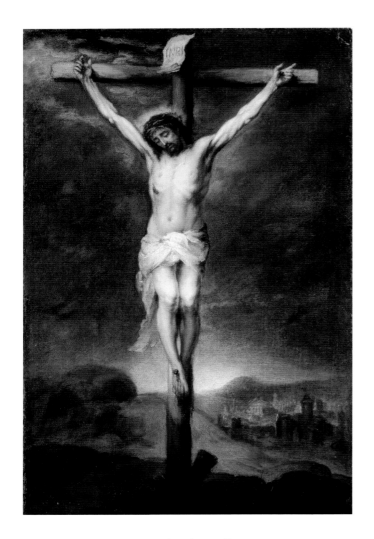

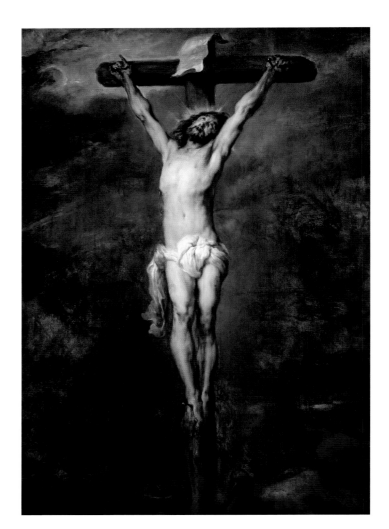

Bartolomé Murillo Anthony van Dyck

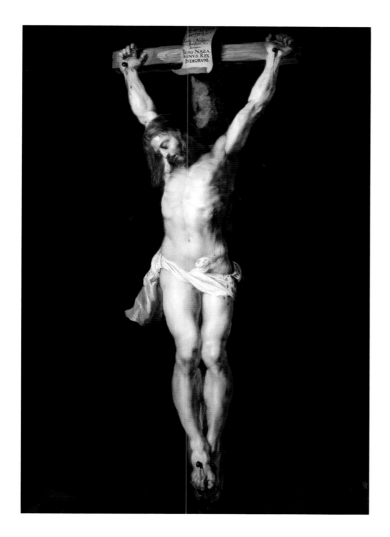

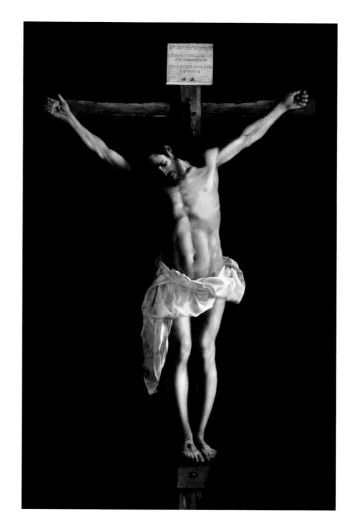

Peter Paul Rubens Francisco de Zurbarán

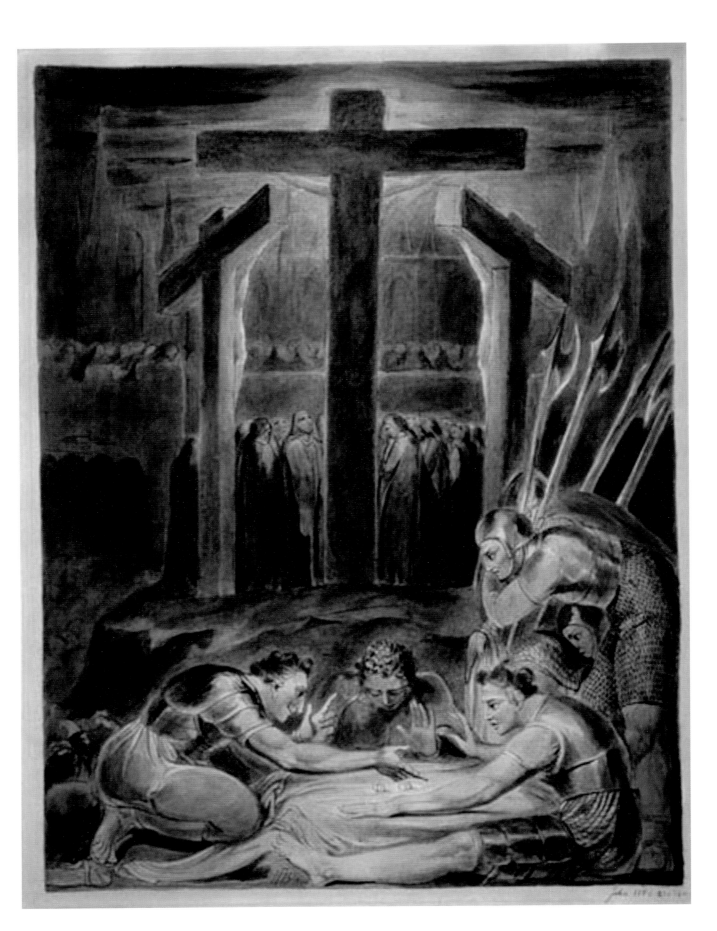

The Soldiers Casting Lots for Christ's Garments

John 19:23-24

Then the soldiers, when they had crucified Jesus, took His garments and made four parts, to every soldier a part; and also the tunic. Now the tunic was without seam, woven from the top throughout. Then they said to one another, "Let's not tear it, but cast lots for it to decide whose it will be," that the Scripture might be fulfilled, which says, "They parted my garments among them. They cast lots for my clothing." Therefore the soldiers did these things.

William Blake 1757-1827
Blake is now considered a seminal figure in the history of the visual arts of the Romantic Age. His visual artistry led 21st-century critic Jonathan Jones to proclaim him "far and away, the greatest artist Britain has ever produced." He lived in London his entire life except for three years spent in Felpham. Blake produced a diverse and symbolically rich œuvre, which embraced the imagination as "the body of God" or "human existence itself." He is held in high regard by later critics for his expressiveness and creativity and the philosophical and mystical undercurrents within his work. Blake was influenced by the ideals and ambitions of the French and American revolutions. Though later he rejected many of these political beliefs, he maintained a cordial relationship with the political activist Thomas Paine.

Christk and the Thief on the Cross *Luke 23:32-43*

There were also others, two criminals, led with Him to be put to death. When they came to the place that is called "The Skull," they crucified Him there with the criminals, one on the right and the other on the left. Jesus said, "Father, forgive them, for they don't know what they are doing." Dividing His garments among them, they cast lots. The people stood watching. The rulers with them also scoffed at Him, saying, "He saved others. Let Him save Himself, if this is the Christ of God, His chosen one!" The soldiers also mocked Him, coming to Him and offering Him vinegar, and saying, "If You are the King of the Jews, save Yourself!" An inscription was also written over Him in letters of Greek, Latin, and Hebrew: "THIS IS THE KING OF THE JEWS."

One of the criminals who was hanged insulted Him, saying, "If you are the Christ, save Yourself and us!" But the other answered, and rebuking him said, "Don't you even fear God, seeing you are under the same condemnation? And we indeed justly, for we receive the due reward for our deeds, but this man has done nothing wrong." He said to Jesus, "Lord, remember me when You come into Your Kingdom." Jesus said to him, "Assuredly I tell you, today you will be with Me in Paradise."

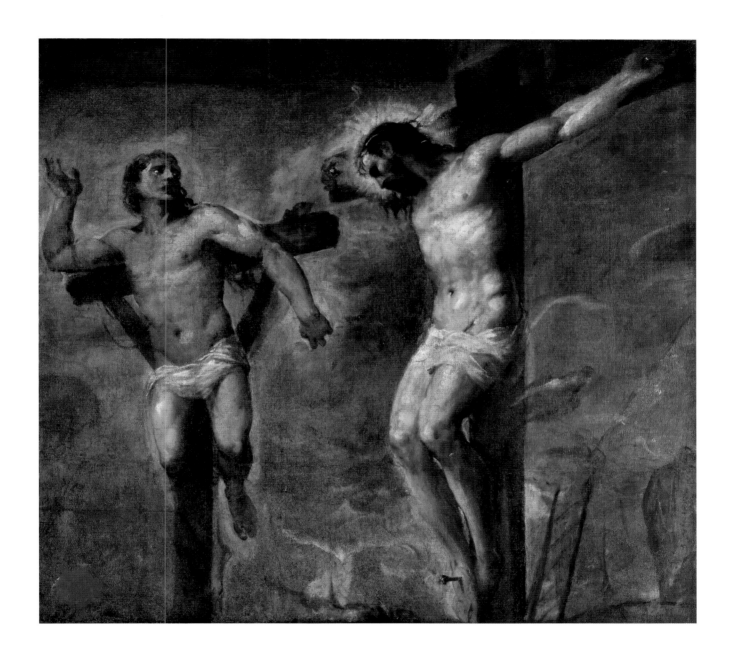

Tiziano Vecelli 1488-1576
Known in English as Titian (TISH-ən), Vecelli was an Italian painter considered the essential member of the 16th-century Venetian school. Recognized by his contemporaries as "The Sun Amidst Small Stars," Titian was one of the most versatile Italian painters, equally adept with portraits, landscape backgrounds, and mythological and religious subjects. His painting methods, particularly in the application and use of color, exercised a profound influence on painters of the late Italian Renaissance and future generations of Western art. Titian's artistic manner changed drastically during his long life, but he retained a lifelong interest in color. Although his mature works may not contain the vivid, luminous tints of his early pieces, their loose brushwork and subtlety of tone were without precedent in the history of Western painting.

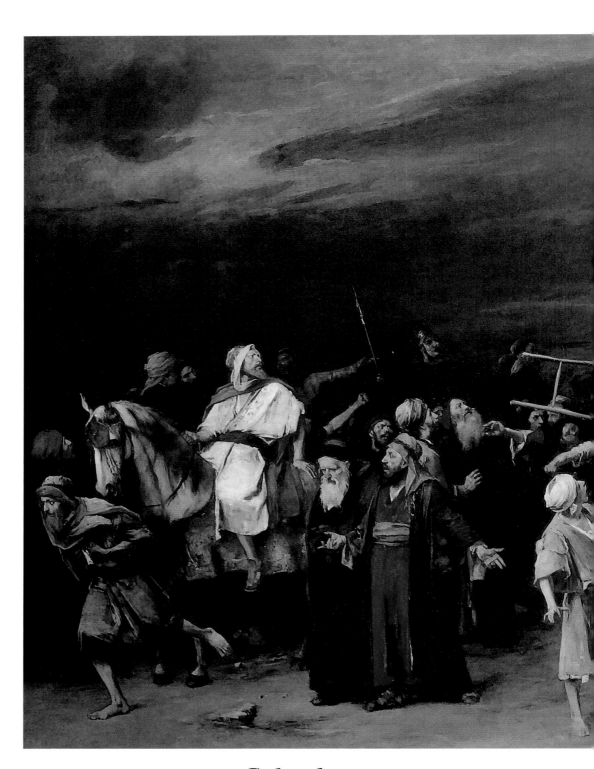

Golgotha

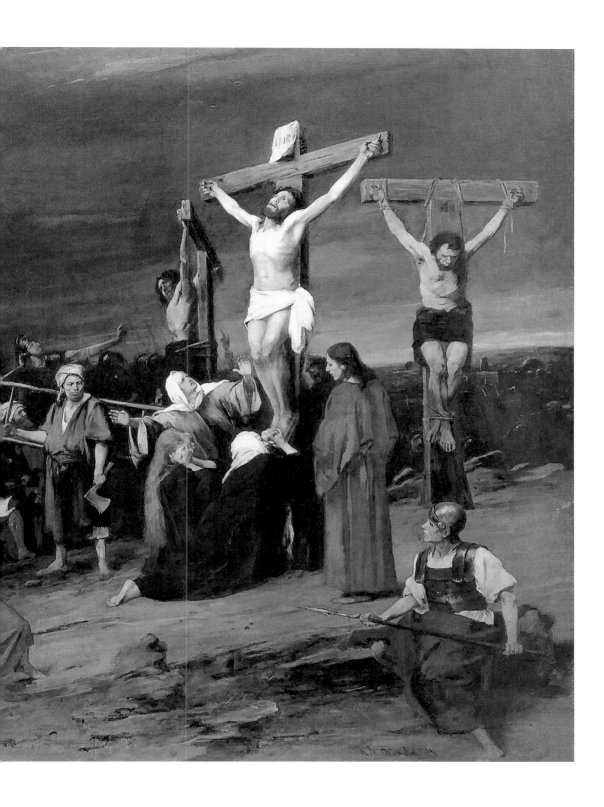

Mihály Munkácsy 1844-1900
Although Munkácsy, who was very conscious about earthly comfort and social prestige, became a celebrity, he was always unsure and constantly questioning his talent. In the summer of 1896, Munkácsy's health sharply declined. After treatment in Baden-Baden, he retired to Paris. Later, he was taken to a mental hospital at Endenich near Bonn, where he collapsed and died May 1, 1900. Munkácsy was buried in the Kerepesi Cemetery, Budapest.

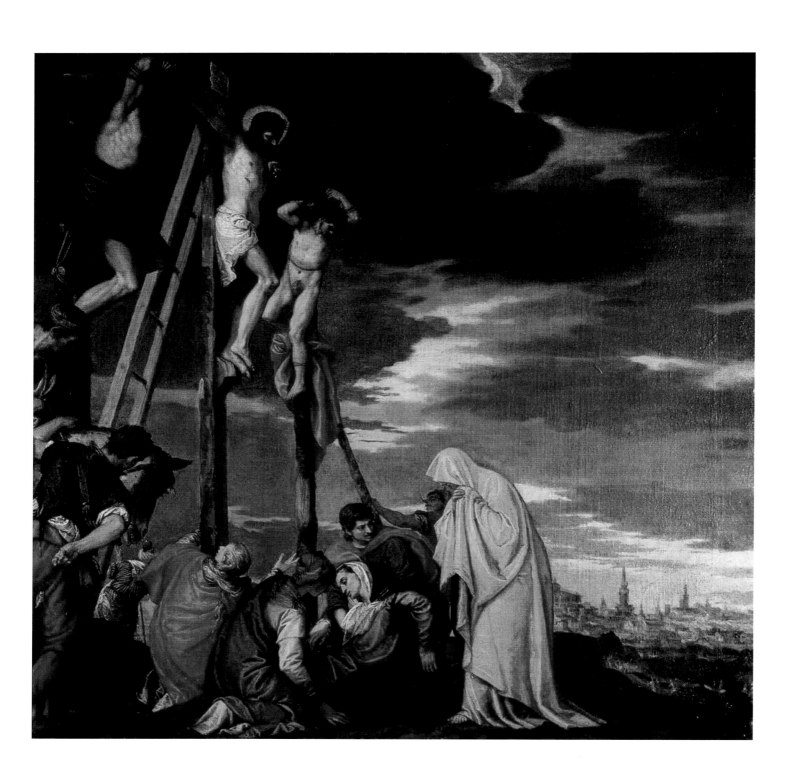

The Crucifixion *Matthew 27:37-56*

They set up over His head the accusation against Him written, "THIS IS JESUS, THE KING OF THE JEWS."

Now from the sixth hour there was darkness over all the land until the ninth hour. About the ninth hour Jesus cried with a loud voice, saying, "Eli, Eli, lama sabachthani?" That is, "My God, My God, why have you forsaken Me?" Some of them who stood there, when they heard it, said, "This man is calling Elijah." Immediately one of them ran and took a sponge, filled it with vinegar, put it on a reed, and gave Him a drink. The rest said, "Let Him be. Let's see whether Elijah comes to save Him." Jesus cried again with a loud voice, and yielded up His spirit. Behold, the veil of the temple was torn in two from the top to the bottom. The earth quaked and the rocks were split. The tombs were opened, and many bodies of the saints who had fallen asleep were raised; and coming out of the tombs after His resurrection, they entered into the holy city and appeared to many. Now the centurion and those who were with him watching Jesus, when they saw the earthquake and the things that were done, were terrified, saying, "Truly this was the Son of God!"

Many women were there watching from afar, who had followed Jesus from Galilee, serving Him. Among them were Mary Magdalene, Mary the mother of James and Joses, and the mother of the sons of Zebedee.

Paolo Veronese 1528-1588
Veronese is considered one of the preeminent representatives of the Venetian School of Painting at the height of the Italian Renaissance. Under the tutelage of Antonio Badile, he studied Giulio Romano, Raphael, Parmigianino, and Michelangelo. He was tremendously influenced by Mannerist art and became known for his mastery of color and his complex multi-figure compositions and intricate depictions of architecture. Veronese was a strong influence for later generations of Italian painters, including Sebastiano Ricci and Giovanni Battista Tiepolo. He also was a seminal figure for 19th-century French painters across a range of disparate artistic movements, from Eugène Delacroix to Paul Cézanne.

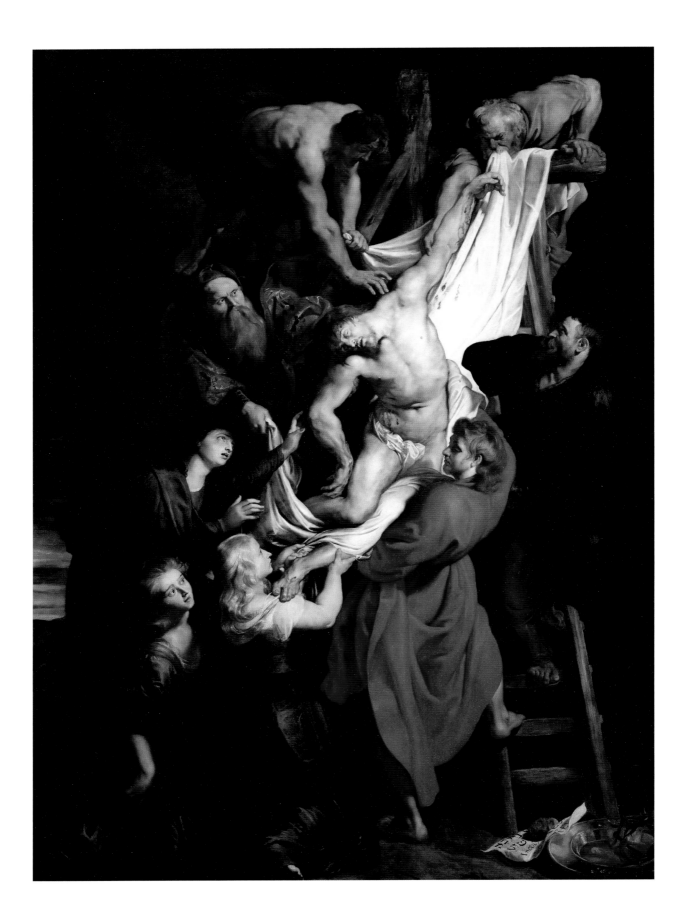

Descent from the Cross *John 19:38-39*

After these things, Joseph of Arimathea, being a

disciple of Jesus, but secretly for fear of the Jews,

asked of Pilate that he might take away Jesus' body.

Pilate gave him permission. He came therefore and

took away His body. Nicodemus, who at first came

to Jesus by night, also came bringing a mixture of

myrrh and aloes, about a hundred Roman pounds.

Peter Paul Rubens 1577-1640

Theophile Silvestre wrote, in his *On Rubens' Descent from the Cross–1868*, "The principal subject is composed of nine figures: at the top of two ladders, workers are lowering the body of Christ with the aid of a shroud which one of them holds in his teeth, the other in the left hand. Bracing themselves firmly against the arms of the cross, each bends forward to guide the Christ with the hand that is left free while the Apostle John, with one foot on the ladder and his back arched, supports him most energetically. One of the Savior's feet comes to rest on the beautiful shoulder of the Magdalene, grazing her golden hair. Joseph of Arimathea and Nicodemus, placed midway on ladders so as to face each other, form, together with the two workmen in the upper part of the picture, a square of vigorous but plebeian figures. Mary, Jesus' mother, standing at the foot of the sacrificial tree, extends her arms towards her Son, and Mary Cleophas kneeling, gathers up her robe. On the ground are seen the superscription and a copper basin where the crown of thorns and the nails of the Crucifixion lie in the congealed blood."

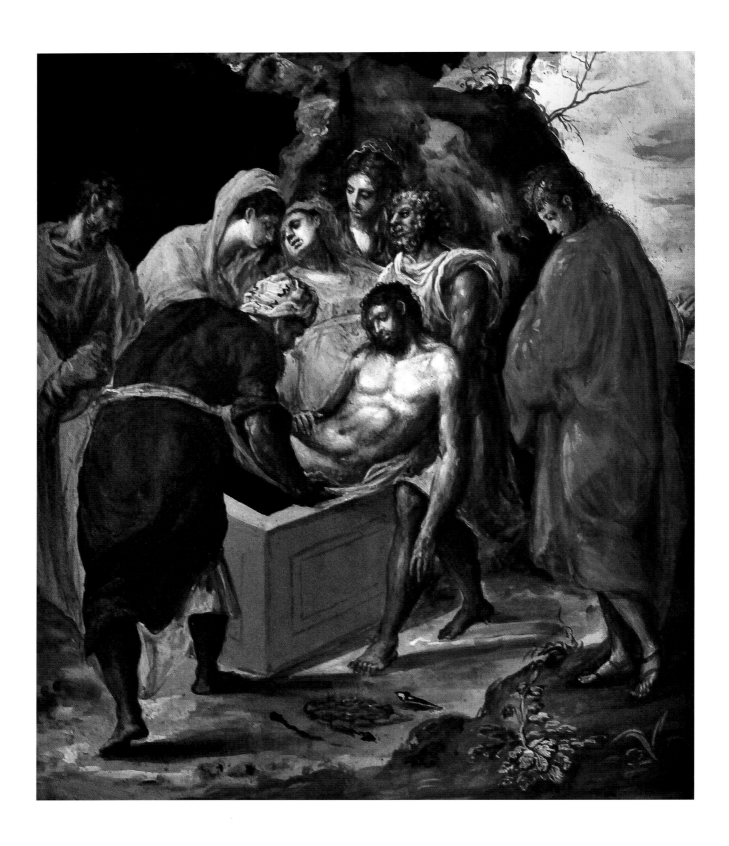

Jesus Is Buried *John 19:40-42*

So they took Jesus' body, and bound it in linen cloths with the spices, as the custom of the Jews is to bury. Now in the place where He was crucified there was a garden. In the garden was a new tomb in which no man had ever yet been laid. Then, because of the Jews' Preparation Day (for the tomb was near at hand), they laid Jesus there.

El Greco 1541-1614

El Greco's dramatic and expressionistic style was met with puzzlement by his contemporaries but found appreciation by the 20th century. He is regarded as a precursor of both Expressionism and Cubism. At the same time, his personality and works were a source of inspiration for poets and writers such as Rainer Maria Rilke and Nikos Kazantzakis. Modern scholars have characterized El Greco as an artist so individual that he belongs to no conventional school. He is best known for tortuously elongated figures and often fantastic or phantasmagorical pigmentation, marrying Byzantine traditions with Western painting.

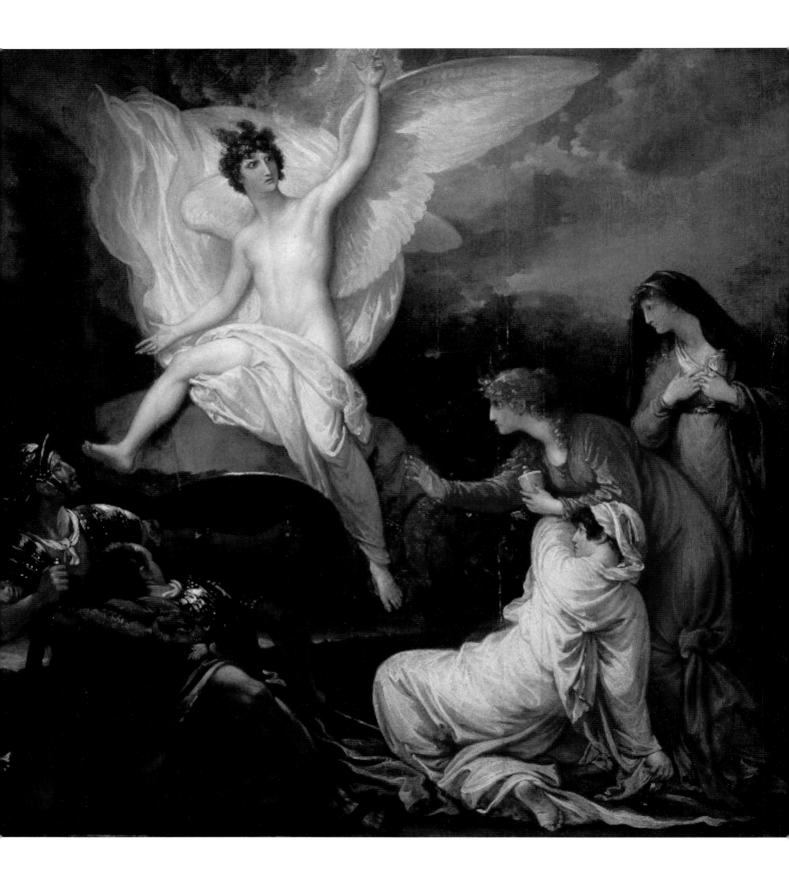

Jesus Is Risen! *Matthew 28:1-7*

Now after the Sabbath, as it began to dawn on the first day of the week,

Mary Magdalene and the other Mary came to see the tomb. Behold,

there was a great earthquake, for an angel of the Lord descended from

the sky and came and rolled away the stone from the door and sat on it.

His appearance was like lightning, and his clothing white as snow. For

fear of him, the guards shook, and became like dead men. The angel

answered the women, "Don't be afraid, for I know that you seek Jesus,

who has been crucified. He is not here, for He has risen, just like He said.

Come, see the place where the Lord was lying. Go quickly and tell His

disciples, 'He has risen from the dead, and behold, He goes before you

into Galilee; there you will see Him.' Behold, I have told you."

Benjamin West 1738-1820
West is the first internationally recognized artist to hail from the New World. He became a prominent portrait painter in Philadelphia and New York before traveling to Europe to immerse himself in the Italian Old Masters and Greek and Roman art. There he took up the newly forming Neoclassical style and painted several large-scale history paintings wildly popular with the public. He soon gained valuable patronage and toured Europe, eventually settling in London. He impressed George III and was primarily responsible for the launch of the Royal Academy, of which he became the second president. He was appointed historical painter to the court and Surveyor of the King's Pictures. West also painted religious subjects, as in his colossal work *The Preservation of St. Paul* after a Shipwreck at Malta, at the Chapel of St. Peter and St. Paul in Greenwich, and *Christ Healing the Sick*, presented to the National Gallery.

Peter and John Running to the Tomb *John 20:1-10*

Now on the first day of the week, Mary Magdalene went early, while it was still dark, to the tomb, and saw that the stone had been taken away from the tomb. Therefore she ran and came to Simon Peter and to the other disciple whom Jesus loved, and said to them, "They have taken away the Lord out of the tomb, and we don't know where they have laid Him!" Therefore Peter and the other disciple went out, and they went toward the tomb. They both ran together. The other disciple outran Peter and came to the tomb first. Stooping and looking in, he saw the linen cloths lying there; yet he didn't enter in. Then Simon Peter came, following him, and entered into the tomb. He saw the linen cloths lying, and the cloth that had been on His head, not lying with the linen cloths, but rolled up in a place by itself. So then the other disciple who came first to the tomb also entered in, and he saw and believed. For as yet they didn't know the Scripture, that He must rise from the dead. So the disciples went away again to their own homes.

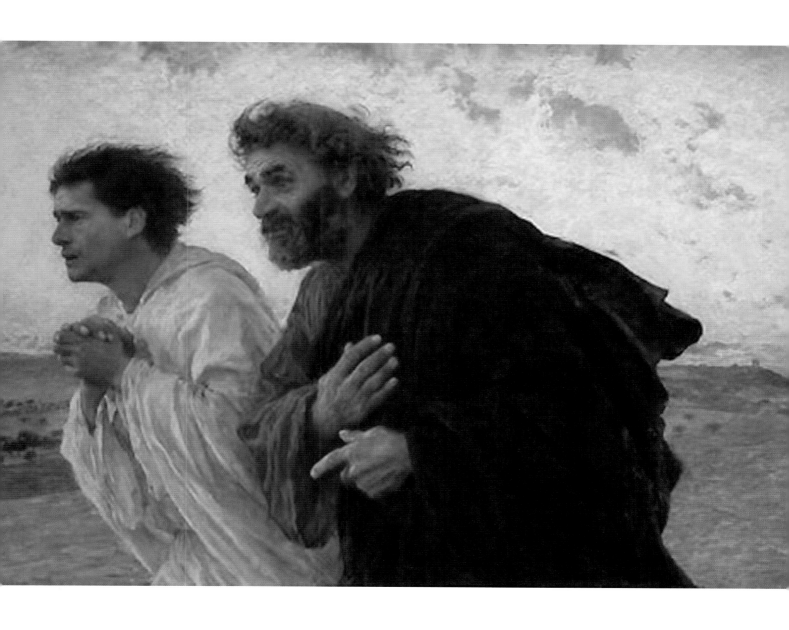

Eugène Burnand 1850 -1921
Burnand was a prolific Swiss painter and illustrator from Moudon, Switzerland. Born of prosperous parents who taught him to appreciate art and the countryside, he first trained as an architect but quickly realized his vocation was painting. He studied art in Geneva and Paris then settled in Versailles. He traveled widely throughout his life and was primarily a realist painter of nature. Burnand was not only a deeply religious man but also a good family man who kept detailed records of his life and work that facilitate a thorough understanding of his methods and motives. His wife Julia and eight children, including two sets of twins, moved with him as his work took him around France and Switzerland. He spent his later years in Paris, where he died a celebrated and well-respected artist both in Switzerland and France.

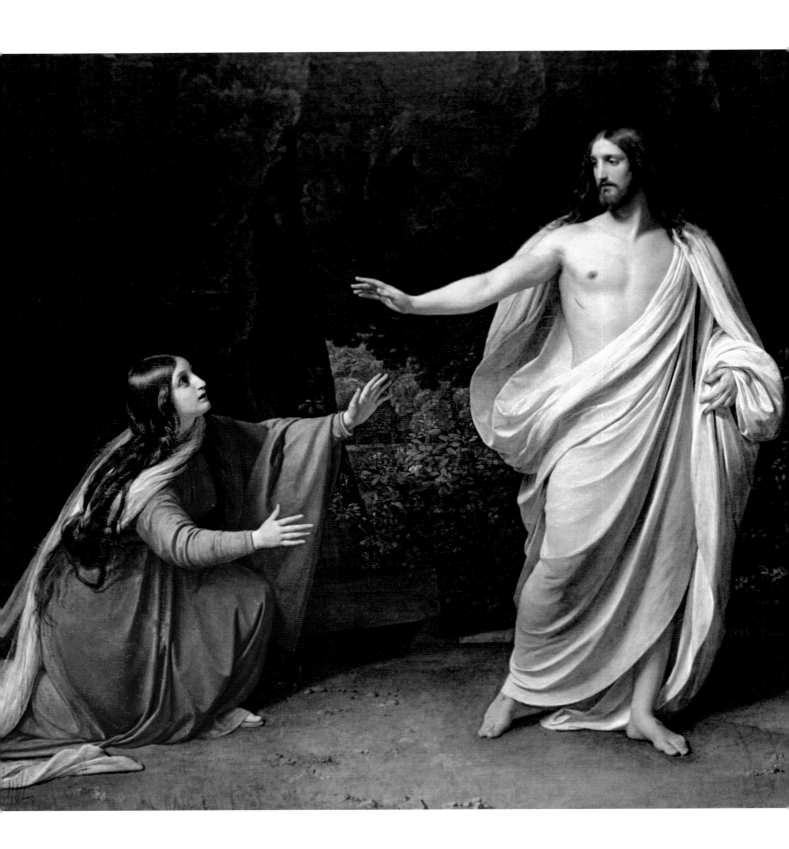

Risen Jesus Meets Mary *John 20:11-18*

But Mary was standing outside at the tomb weeping. So as she wept, she stooped and looked into the tomb, and she saw two angels in white sitting, one at the head and one at the feet, where the body of Jesus had lain. They asked her, "Woman, why are you weeping?" She said to them, "Because they have taken away my Lord, and I don't know where they have laid him." When she had said this, she turned around and saw Jesus standing, and didn't know that it was Jesus. Jesus said to her, "Woman, why are you weeping? Who are you looking for?" She, supposing Him to be the gardener, said to Him, "Sir, if you have carried Him away, tell me where you have laid Him, and I will take Him away." Jesus said to her, "Mary." She turned and said to him, "Rabboni!" which is to say, "Teacher!" Jesus said to her, "Don't hold me, for I haven't yet ascended to My Father; but go to My brothers and tell them, 'I am ascending to My Father and your Father, to My God and your God.'" Mary Magdalene came and told the disciples that she had seen the Lord, and that He had said these things to her.

Alexander Andreyevich Ivanov 1806-1858
Ivanov was a Russian painter who adhered to the waning tradition of Neoclassicism but found little sympathy with his contemporaries. At the age of 11, Ivanov entered the Imperial Academy of Arts and studied at his father's course together with Karl Briullov. Ivanov traveled to Europe in 1830, first to Germany, then to Italy. His first works in Rome were copies of *The Creation of Adam* of the Sistine Chapel and some drafts of Biblical scenes. His painting *Appearance of Jesus Christ to Maria Magdalena* had great success both in Rome and St. Petersburg. The Russian Imperial Academy of Arts granted Ivanov an honorary academic degree in 1836. He spent most of his life in Rome, where he befriended Gogol. Alexander Ivanov returned home in 1857, but his life was suddenly cut short; he died of cholera on July 3, 1858, in Petersburg. Ivanov's grave is in the Artists' corner at the Tikhvin Cemetery of the Alexander Nevski Monastery.

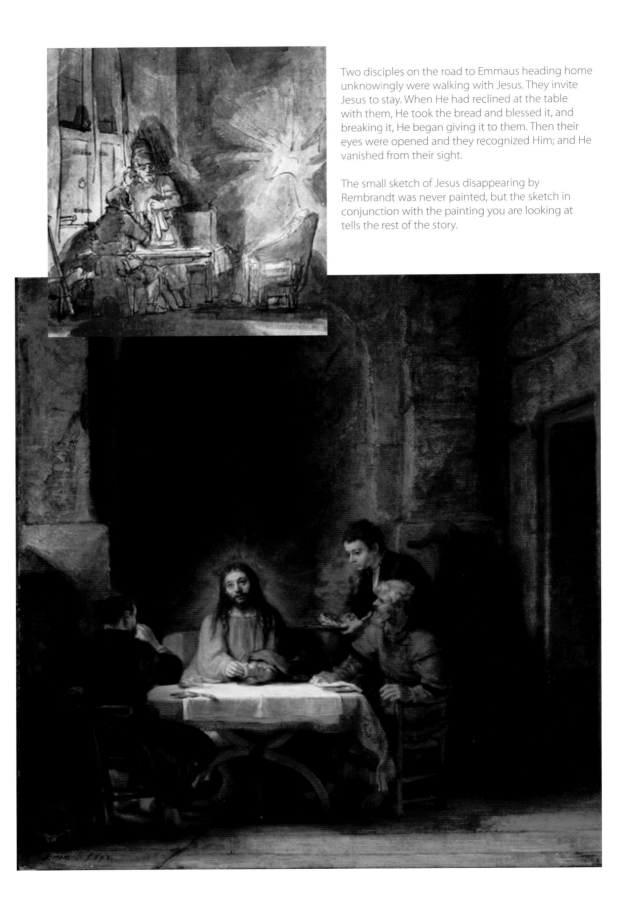

Two disciples on the road to Emmaus heading home unknowingly were walking with Jesus. They invite Jesus to stay. When He had reclined at the table with them, He took the bread and blessed it, and breaking it, He began giving it to them. Then their eyes were opened and they recognized Him; and He vanished from their sight.

The small sketch of Jesus disappearing by Rembrandt was never painted, but the sketch in conjunction with the painting you are looking at tells the rest of the story.

Road to Emmaus *Luke 24:13-32*

Behold, two of them were going that very day to a village named Emmaus, which was about seven miles from Jerusalem. They talked with each other about all of these things which had happened. While they talked and questioned together, Jesus Himself came near, and went with them. But their eyes were kept from recognizing Him. He said to them, "What are you talking about as you walk, and are sad?" One of them, named Cleopas, answered Him, "Are you the only stranger in Jerusalem who doesn't know the things which have happened there in these days?" He said to them, "What things?" They said to Him, "The things concerning Jesus the Nazarene, who was a prophet mighty in deed and word before God and all the people; and how the chief priests and our rulers delivered Him up to be condemned to death, and crucified Him. But we were hoping that it was He who would redeem Israel. Yes, and besides all this, it is now the third day since these things happened.

Continued in Appendix

Rembrandt 1660-1669
Rembrandt is generally considered one of the greatest painters in European art and the most important in Dutch history. His contributions to art in a period of great wealth and cultural achievement that historians call the Dutch Golden Age are, in many ways, antithetical to the Baroque style that dominated Europe at that time. Rembrandt was extremely prolific and innovative, giving rise to important new genres in painting. Among the more prominent characteristics of Rembrandt's work is his use of chiaroscuro (the theatrical use of light and dark shadows). Because of his empathy for the human condition, he has been called one of the greatest visual prophets of civilization.

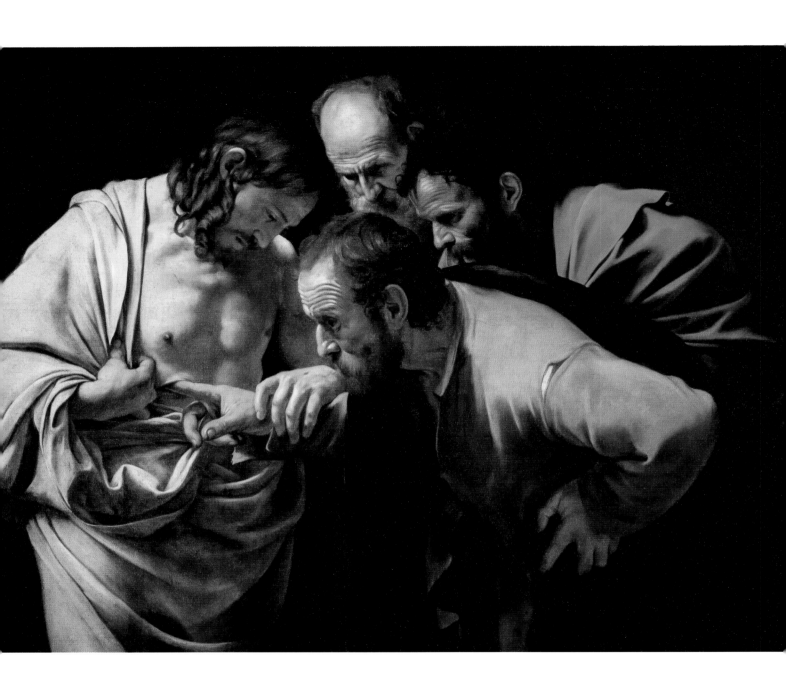

Doubting Thomas *John 20:24-29*

Thomas, one of the twelve, called Didymus, wasn't with them when Jesus came. The other disciples therefore said to him, "We have seen the Lord!" But he said to them, "Unless I see in His hands the print of the nails, put my finger into the print of the nails, and put my hand into His side, I will not believe."

After eight days, again His disciples were inside and Thomas was with them. Jesus came, the doors being locked, and stood in the middle, and said, "Peace be to you." Then He said to Thomas, "Reach here your finger, and see My hands. Reach here your hand, and put it into My side. Don't be unbelieving, but believing." Thomas answered Him, "My Lord and My God!" Jesus said to him, "Because you have seen Me, you have believed. Blessed are those who have not seen and have believed."

Caravaggio 1571-1610
Caravaggio's influence on the new Baroque style that emerged from Mannerism was profound. It can be seen directly or indirectly in the work of Peter Paul Rubens, Jusepe de Ribera, Gian Lorenzo Bernini, and Rembrandt, and artists in the following generation heavily under his influence were called the "Caravaggisti" as well as tenebrists or tenebrosi ("shadowists"). Caravaggio's innovations inspired Baroque painting, but the Baroque incorporated the drama of his chiaroscuro without the psychological realism. The style evolved and fashions changed, and Caravaggio fell out of favor. In the 20th century, interest in his work revived, and his importance to the development of Western art was reevaluated. The 20th-century art historian André Berne-Joffroy stated, "What begins in the work of Caravaggio is, quite simply, modern painting."

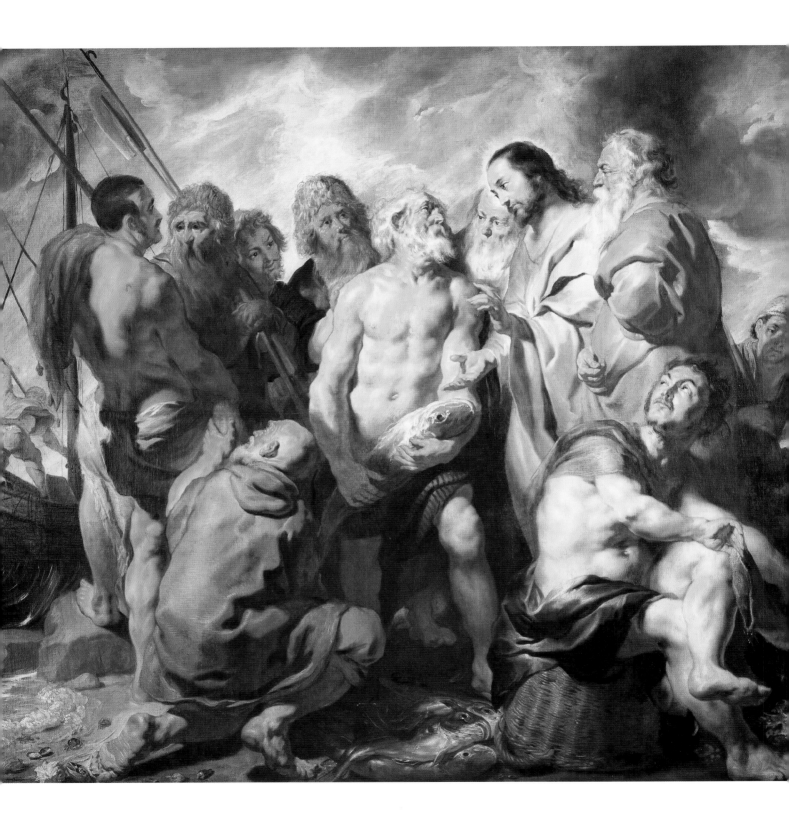

Jesus Appears at the Sea of Galilee

John 21:1-10

After these things, Jesus revealed himself again to the disciples at the sea of Tiberias. He revealed himself this way. Simon Peter, Thomas called Didymus, Nathanael of Cana in Galilee, and the sons of Zebedee, and two others of his disciples were together. Simon Peter said to them, "I'm going fishing." They told him, "We are also coming with you." They immediately went out and entered into the boat. That night, they caught nothing. But when day had already come, Jesus stood on the beach; yet the disciples didn't know that it was Jesus. Jesus therefore said to them, "Children, have you anything to eat?"

They answered him, "No." He said to them, "Cast the net on the right side of the boat, and you will find some." They cast it therefore, and now they weren't able to draw it in for the multitude of fish. That disciple therefore whom Jesus loved said to Peter, "It's the Lord!" So when Simon Peter heard that it was the Lord, he wrapped his coat around himself (for he was naked), and threw himself into the sea. But the other disciples came in the little boat (for they were not far from the land, but about two hundred cubits away), dragging the net full of fish. So when they got out on the land, they saw a fire of coals there, with fish and bread laid on it. Jesus said to them, "Bring some of the fish which you have just caught."

Jacob Jordaens 1593 -1678
Like Rubens, Jordaens painted altarpieces, mythological, and allegorical scenes. After 1640—the year Rubens died—he was the most important painter in Antwerp for large-scale commissions, and the status of his patrons increased in general. However, he is best known today for his numerous large genre scenes based on the Bible. Jordaens' main artistic influences, besides Rubens and the Brueghel family, were northern Italian painters such as Jacopo Bassano, Paolo Veronese, and Caravaggio.

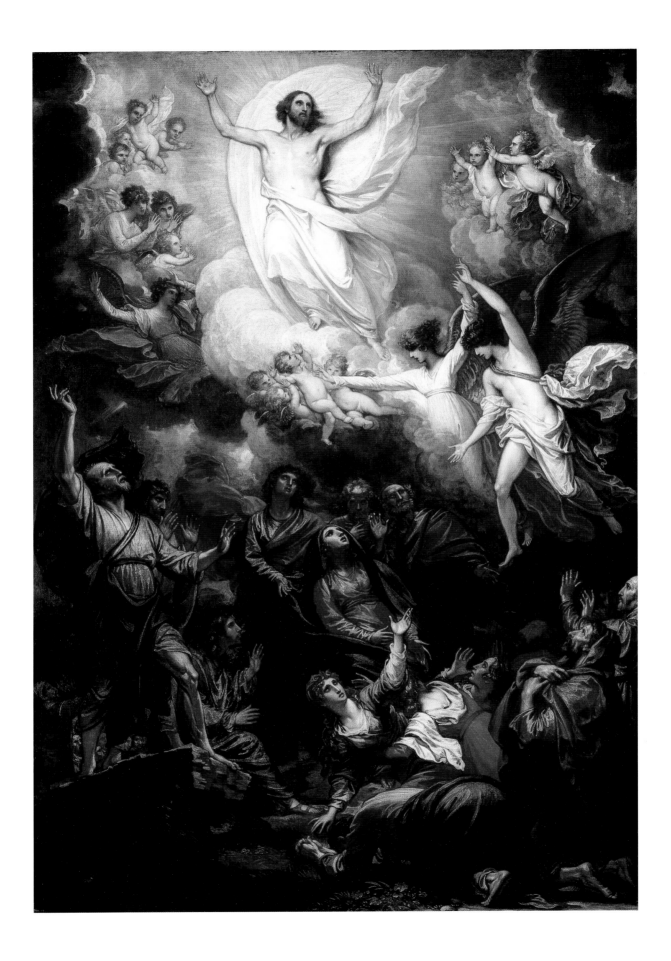

The Ascension *Acts 1:6-11*

Therefore, when they had come together, they asked Him, "Lord, are you now restoring the kingdom to Israel?" He said to them, "It isn't for you to know times or seasons which the Father has set within his own authority. But you will receive power when the Holy Spirit has come upon you. You will be witnesses to me in Jerusalem, in all Judea and Samaria, and to the uttermost parts of the earth."

When He had said these things, as they were looking, He was taken up, and a cloud received Him out of their sight. While they were looking steadfastly into the sky as He went, behold, two men stood by them in white clothing, who also said, "You men of Galilee, why do you stand looking into the sky? This Jesus, who was received up from you into the sky, will come back in the same way as you saw Him going into the sky."

Benjamin West 1738-1820
West was hugely influential for a new generation of American artists, including Gilbert Stuart and John Singleton Copley, who shaped the early Republic's visual identity. While his reputation languished with later critics and historians, West's eventual transition to Romanticism and embracing current trends has prompted some scholars to consider West one of the first modern artists. In August 1763, West arrived in England on what he initially intended as a visit on his way back to America, when, in fact, he never returned to America. Benjamin West was known in England as the "American Raphael." He said, "Art is the representation of human beauty, ideally perfect in design, graceful and noble in attitude."

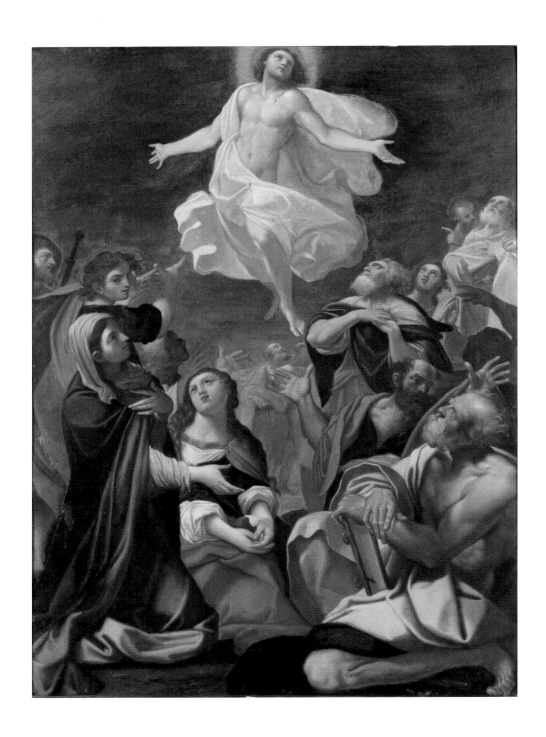

The Ascension *Luke 24:50-53*

And He led them out as far as Bethany, and He lifted up His hands and blessed them. While He was blessing them, He part-ed from them and was carried up into heaven. And they, after worshiping Him, returned to Je-rusalem with great joy, and were continually in the temple praising God.

Giacomo Cavedone 1577-1660
Cavedone was an Italian Baroque painter of the Bolognese School. He belonged to the generation of Carracci-inspired or trained painters, including Giovanni Andrea Donducci, Alessandro Tiarini, Lucio Massari, Leonello Spada and Lorenzo Garbieri. He was born in Sassuolo, near Modena, and obtained a three-year stipend to apprentice with Bernardino Baldi and Annibale Carracci. In the autumn of 1609, he sojourned in Rome for a year to work under Guido Reni. He became one of Ludovico Carracci's primary assistants, and upon Ludovico's death in 1619, became Caposindaco of the Accademia degli Incamminati. His career was cut short by a set of misfortunes, including a 1623 fall from a church scaffold and, in 1630, the death of his wife and children from the plague. He lived until 1660 and died in poverty.

THE STORY OF JESUS CHRIST IS NOT OVER, IT'S JUST THE BEGINNING.

The Scriptures make it very clear, that someday, possibly very soon, the LORD will return for those that love Him, trusted Him and placed their faith in the work that He did on the cross.

Following are scripture verses that support His glorious return.

The Glorious Return of Jesus Christ
as prophesied in both the Old & New Testament

Psalm 2:1-12 God decrees in Eternity past that His Son will reign

Psalm 110 God instructs the Messiah to sit in heaven and wait for God to arrange the defeat of His enemies

Matthew 26:63-64 Jesus predicts He will return

Acts 1:9-11 The angels predict that Jesus will return

2 Thessalonians 1:1-10 The Apostle Paul predicts Jesus will return

Conditions Surrounding Christ's Return
Daniel 7:9-14 The scene in heaven

Zechariah 12:14, 14:1-2 The battle of Jerusalem

Zechariah 13:8-9 The refining of Israel

Matthew 24:37-51 The world will not be expecting Jesus' return

Revelations 19:11-16 Christ's return as viewed in heaven

Matthew 24:29-31 & Revelation 1:7 Christ's return as viewed from the earth

Revelation 19:17-19 The angelic invitation of the birds to the great feast of God

The Return of Christ and the Ensuing Battle
Zechariah 14:3-4 The moment of Christ's return

Zechariah 12:4-9 Details of the battle

Zechariah 14:12-13, 15 Jesus will plague those fighting against Israel

Revelation 19:20-21 Jesus will achieve total victory over His adversaries

Zechariah 12:10-14, 13:1-2 The repentance of Israel

Matthew 24:31 The world-wide gathering of the chosen

Matthew 25:31-46 Jesus' judgement of all the survivors

Psalm 24:7-10 Jesus' grand entrance into Jerusalem

Zechariah 14:9 Jesus' world-wide reign

Illustration Artist: Keith Kapple

In Acts 1:11 as the Apostles watched in awe the ascension of Jesus, an angel standing behind said, "men of Galilee, why do you stand looking into the sky? This Jesus, who was taken up from you into heaven, will come in just the same way as you have watched Him go into heaven." In Revelation 1:7 it tells us; "BEHOLD, HE IS COMING WITH THE CLOUDS, and every eye will see Him, even those who pierced Him. All the tribes of the earth will mourn over Him. Even so, Amen."

Think about this; thanks to technology, CBS, NBC, ABC, MSNBC, CNN, FOX NEWS, the BBC and every other news network around the world will have their cameras rolling, so every person throughout the world will be watching His glorious return. Trust me when I say this, you don't want to be watching this on your tv or cell phone.

By writing this book, it is my hope and prayer that your heart will be open to the call of Jesus. As He said to Nicodemus: "you must be born again." and then in John 3:16 Jesus said, "For God so loved the world, that He gave His only begotten Son, that whoever believes in Him will not perish, but have eternal life."

The painting in the photograph is *The Crucifixion*, by Francisco de Zurbarán, c.1627.
Photo by Rich Timmons, 1997 - Chicago Museum of Art

So, now what?

I hope you found inspiration in the story of Jesus Christ through the chosen verses, along with the artist's rendition of the event described in the passages. Before you close this book and place it on your bookshelf, may I ask you to take a very close look at the photo on the left hand page?

I'd like to ask you a direct question. Which one are you?

Are you one of the two weary folks sitting on the bench, occupied planning their next stop at the exhibit? Or do you identify with the gentleman standing alone with hands on hips, looking for the artist's signature? Or are you one of the two people looking intently at the face of Jesus hanging on the cross?

Consider thinking through just one bible verse with me. Jesus had a private conversation with Nicodemus, a prominent religious leader. He was very serious about wanting to know truth. As they met, Jesus shared, "For God so loved the world that He gave His only begotten Son that whoever believes in Him shall not perish, but have eternal life." John 3:16

There are three parts to this 25 word verse.

Part 1: For God so loved the world. - God created the world; by saying the "world", He is saying, He loves all people; the good, the bad, and the really bad. He loves us all.

Part 2: He gave His only begotten Son (Jesus). - Jesus was sent by God to die for the sins of all mankind. The religious and political leaders of that day in Israel were corrupt, so they decided to kill Jesus. It was all part of God's plan. If you have read and studied the paintings, you know what happened. He was brutally tortured beyond recognition and then crucified and left to die.

Part 3: then God said, "that whoever would believe in Him would not perish but have eternal life." Consider the thief condemned to die, hanging on a cross next to Jesus. He could do nothing other than realize that Jesus was, in fact, the Savior, while he was a sinner condemned to die. He asked Jesus to remember him, and Jesus said, "Truly I say to you, today you shall be with Me in Paradise." His response to Jesus? He believed!

Now think about this. In a profound way this photograph represents the entire human race. There are those not interested at all in knowing God. There are those that may seem interested in knowing God, but are always looking in the wrong places. And then, there are those that look to Jesus, believing He died on the cross for the payment of their sins, so that they can now begin a true relationship with God.

So, which one are you?

Appendix

Jesus Raises Lazarus from the Dead

continued... The Jews therefore said, "See how much affection He had for him!" Some of them said, "Couldn't this man, who opened the eyes of him who was blind, have also kept this man from dying?"

Jesus therefore, again groaning in Himself, came to the tomb. Now it was a cave, and a stone lay against it. Jesus said, "Take away the stone." Martha, the sister of him who was dead, said to Him, "Lord, by this time there is a stench, for he has been dead four days." Jesus said to her, "Didn't I tell you that if you believed, you would see God's glory?" So they took away the stone from the place where the dead man was lying. Jesus lifted up His eyes and said, "Father, I thank you that you listened to Me. I know that You always listen to Me, but because of the multitude standing around I said this, that they may believe that You sent Me." When He had said this, He cried with a loud voice, "Lazarus, come out!" He who was dead came out, bound hand and foot with wrappings, and his face was wrapped around with a cloth. Jesus said to them, "Free him, and let him go."

Therefore many of the Jews who came to Mary and saw what Jesus did believed in Him. But some of them went away to the Pharisees and told them the things which Jesus had done. The chief priests therefore and the Pharisees gathered a council, and said, "What are we doing? For this man does many signs. If we leave Him alone like this, everyone will believe in Him, and the Romans will come and take away both our place and our nation."

Road to Emmaus

continued... Also, certain women of our company amazed us, having arrived early at the tomb; and when they didn't find His body, they came saying that they had also seen a vision of angels, who said that He was alive. Some of us went to the tomb and found it just like the women had said, but they didn't see Him." He said to them, "Foolish people, and slow of heart to believe in all that the prophets have spoken! Didn't the Christ have to suffer these things and to enter into his glory?" Beginning from Moses and from all the prophets, He explained to them in all the Scriptures the things concerning himself.

They came near to the village where they were going, and He acted like He would go further. They urged Him, saying, "Stay with us, for it is almost evening, and the day is almost over." He went in to stay with them. When He had sat down at the table with them, He took the bread and gave thanks. Breaking it, He gave it to them. Their eyes were opened and they recognized Him; then He vanished out of their sight. They said to one another, "Weren't our hearts burning within us while He spoke to us along the way, and while He opened the Scriptures to us?"

A Special Thank You

I am humbled and thankful to my family, friends and colleagues who have prayed with me, encouraged me, advised me, and actually contributed many hours of support.

I thought it would be best to list my supporters and helpers in the order they stepped into my project, *Come... meet Jesus.*

Erik Adamonis from Alamy for helping me find the best and most unique paintings.

Lauren Stabilito was tremendously helpful with design and production.

Karen Burgman who was so kind to write a humbling foreword.

Carmen Coe led me to the correct art for the cover.

Carol Hoffner for tweaking the title.

Julie Timmons, April Masterson and Bette Jo Smith for their faithfulness to proofreading every word from cover to cover.

What would I do without a prayer and strategic support team. A special thank you to Frank & Tracy Bradley, Mike & Cathy Brickley, the Burgman Family, Joe & Cindy Castillo, Tommy & Linda Chriswell, David & Beth Collum, Jack & Kaye Dundas, Mike & Danene Foti, John & Renee Hessler, John W. & Lauren Hessler, Carol Hoffner, Wayne & Carol Lynch, Eric, April & Dylan Masterson, Brian & Susan Middleton, Ed & Cathy O'Brien, Joe & Margo Priest, David & Kim Savage, Scott & Lynne Shaw, Lauren Stabilito, Phil & Linda Thayer.

About the Author

Rich Timmons

Veteran United States Air Force
Past Board Member: Plumstead Christian School (12 yrs)
Board Member: The Pocket Testament League (35 yrs)
Active Member at our Church

I am a lifetime lover of art, especially paintings of Jesus by the masters.

In 1968, I married Julie, my high school sweetheart. We have three special children and one special foster son. We have 12 very special grandchildren and two very, very special great-grand babies.

We are most certainly blessed.

Julie and I both placed our lives into the hands of Jesus as our Lord and Savior in 1977.

My career started in the graphic arts industry and ended 45 years later when we sold our successful marketing firm. We opened a fine art gallery, which led me to the opportunity to teach an art history class at a local college. It was Julie's idea to create a coffee table book from all the research that was required to teach.

We are honored to present to you the incredible story of Jesus through 67 works of art and the sacred writings found in the Gospels of Matthew, Mark, Luke, and John.

We welcome your thoughts and ideas
especially regarding how to get this
Gospel message out.

rt@ComeMeetJesus.art

This QR code will give you a free digital copy of the Gospel of John
that you can read and share with others.

Courtesy of The Pocket Testament League

To order either a printed or digital coffee table book of
Come... meet Jesus for loved ones or friends go to:
www.ComeMeetJesus.art

There are also many other things which Jesus did, which if they would all be written, I suppose that even the world itself wouldn't have room for the books that would be written.

John 21:25